THE COMPLETE GUIDE TO
MANGA
COMPOSITION

Learn the Art of Perspective and Dynamic Storytelling

Shinji Matsuoka

TUTTLE Publishing

Tokyo | Rutland, Vermont | Singapore

Contents

CHAPTER 3 Composition Examples

Creating a Sense of Stability

Making the Protagonist Stand Out

Conveying a Sense of Dynamism

Creating an Original Impression

Why I Wrote This Book

What makes an illustration that instantly captures the heart? It is an image that deeply resonates with one's inner world, evoking emotion. Capturing the meaningful expressions of the characters, employing exceptional drawing skills such as a strong grasp of sketching and color sense, depicting a rich narrative—various elements can bring about an emotional response. "Composition" helps organize these elements, eliminating distraction and enhancing charm.

The elements that evoke an emotional response complement each other and are important for producing the effects intended by the author through careful image composition. This book is a reference guide for composition that will be useful when you catch yourself creating lackluster images with haphazardly arranged characters, wondering how to break away from patterns and habits, or when you can't think of ideas for composition, angles and poses.

If there are compositions presented in this book that you have never tried in your drawings, I encourage you to take on the challenge of mastering them all. You will surely discover something new. For over 10 years, I have been demonstrating my techniques to aspiring illustrators as a lecturer at an academy for manga illustration. Every day, while creating illustrations, I consider with my students the importance of composition and how to make art that works on an emotional level.

I hope that you will feel like you're learning in my classroom when you use this book. I would like to express my sincere thanks to the illustrators who provided the many examples in these pages, as well as the managing editor, who was instrumental in preparing this book.

— **Shinji Matsuoka**

About Composition

Modern paint programs are equipped with many convenient features that assist in the creation of illustrations and comics. By using filters and effects, you can add color to an illustration in an instant. However, there are still few features that automatically adjust the placement of characters and backgrounds to create a "good composition." Someday, as artificial intelligence develops, it might be possible to create compositions with just one click, but currently, this task is left in the hands of the artist.

Unlike mathematics, there are no absolute answers in art—there is no single correct solution. Even if drawn on the same theme, compositions will differ depending on individual illustrator's thought processes and techniques.

However, there are basic principles and rules for creating better compositions. By mastering these through studying this book and making adjustments, you will be able to create captivating single-panel images and powerful manga art. The variety of your drawings will expand dramatically, and drawing will become even more enjoyable.

About the Author

Shinji Matsuoka is an Illustrator and art instructor who was born in Kama City, Fukuoka Prefecture, Japan. He studied under famed Japanese artist Genpei Akasegawa at Gendaishicho-sha Bigakkō, an alternative art school in Japan. He made his debut working for the monthly Japanese manga magazine, *Garo*. He has won several prestigious industry awards, including the Yasuji Tanioka Award and The Choice award from *Illustration* magazine. After working at Yasuji Tanioka Productions, he began freelancing and has been producing illustrations for publishing and advertising. He has been an instructor at design schools and colleges since 2004.

Composition Basics

Here, I will explain the basic knowledge you need to understand composition. I'll cover a range of topics, such as how to give a sense of convincing realism to an image, how to compose arrangements that readers will find appealing, and tips for "leading lines" that highlight the main subject. These will form the foundation for creating attractive illustrations.

What is Composition?

What effect does composition adjustment bring to an illustration? By adding or subtracting elements, you can observe how the impression changes.

Visualizing Ideas

What is important for drawing an attractive illustration? This is a question that illustrators must constantly ask themselves. No matter what kind of illustration it is, it is necessary to carefully consider: What do I want to express? What do I need to draw to convey my ideas and make them understood by the viewer? What is important (and what is not) in the picture?

Illustration creation begins with developing an idea. Then, you give this idea a visual form, which requires "visualizing." Various techniques are required to express the initial idea clearly and effectively.

Basic Composition Considerations

In illustration creation, first, we brainstorm what we want to draw and the scene, and consider how to bring out the charm of the main motif. Think about what to include in the frame and what to omit. Trying out different ways to arrange the elements within the frame is what thinking about composition is about.

The illustration below is composed of motifs such as a girl, a cat, a house, a tree, the sky and the ground. Based on this illustration, on the next page, we consider composition from various perspectives by cropping the image in different ways.

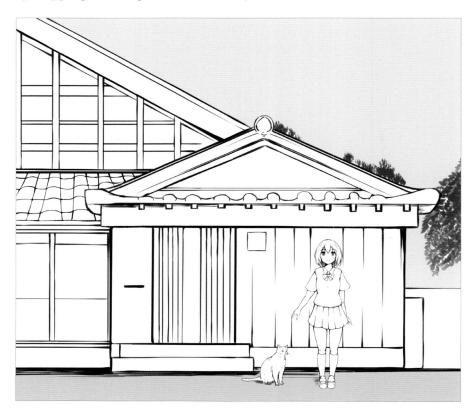

Subtraction and Addition of Elements

Once the protagonist or main element is decided, the next step is to "subtract" elements that might weaken the impression of that protagonist. Conversely, sometimes elements are added to the frame to highlight the protagonist. This is the "addition" process. An illustration of various trials of this subtraction and addition process can be seen in the figures below. Captivating illustrations are born from meticulous planning. Let's explore the process of improving a composition.

Considering the composition is like designing a painting. The origin of the word "design" comes from the Latin word *designare*, which means "to denote a plan with symbols," similar to the word *dessin* ("sketch" in French). It's about turning the planned elements into an illustration. But nothing will start just by thinking—let's pick up a pen and start drawing!

This is a conventional vertical composition showing the protagonist's upper body. By reserving a large portion of the canvas for the protagonist and excluding almost everything else, you can clearly indicate what the main focus is.

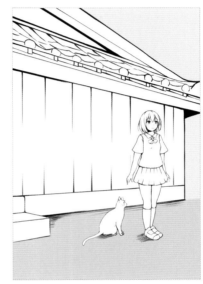

This is an example drawn from a diagonal perspective. By changing the angle, the image, which was flat, now contains the depth of a three-dimensional depiction.

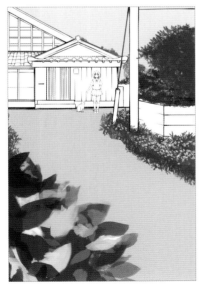

A road has been included in the foreground. The sky has been "subtracted," and vegetation has been "added" along the road. The character is set farther back, but the curve of the road guides the viewer's gaze to the character. Depth is introduced, and an unspoken narrative can be sensed.

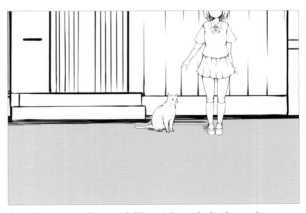

Another approach is to deliberately exclude the main character's facial expression. By not showing the most important feature—the eyes—it fuels the viewer's imagination. The subtraction of the expression provides a unique effect. By depicting a large space in the foreground from a low-angle, the negative space encourages the viewer to imagine the story.

Gathering Ideas Roughly

The first thing you want to decide when drawing an illustration is the motif and theme you want to incorporate. After determining that, you'll consider how to effectively place those elements within the canvas.

Start with an Image Sketch

At the image sketching phase, draw the motifs you want to feature in a broad and simple individual form. Characters, objects and backgrounds are drawn in recognizable line art or silhouettes. Image sketching is a process for organizing ideas. Don't get too bogged down in details; just draw as ideas come to mind.

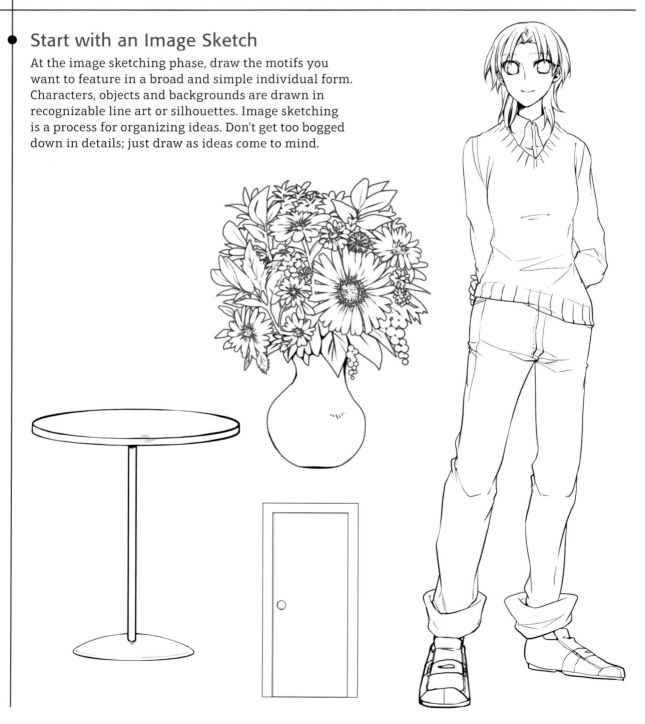

Refine Placement in Rough Sketches

Once you've decided what you want to draw, you'll begin placing elements within a predetermined canvas (frame). Just as in architecture, theater or musical compositions, illustrations are also made up of various elements that harmoniously complement each other. If you try to highlight every element, the image will become chaotic. The position, angle, direction and size of elements can greatly alter the meaning of a scene or how a story is conveyed. Experiment with these factors in mind, creating a composition that's best suited for the setting or theme.

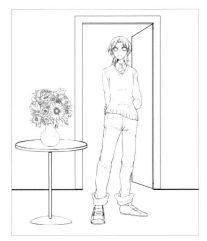

This is a composition where the character and background elements, such as a table, are in harmony. This provides stability, making it suitable for conveying the scene's setting to readers.

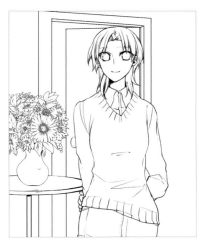

This composition shows the upper body of the character placed at the forefront of the image. A vase, a door and a table serve to highlight the character.

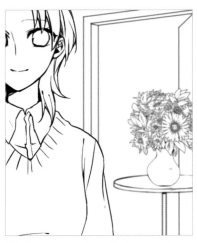

This is a composition that zooms in on a face oriented directly toward the viewer, which falls only partially within the frame. This composition is effective when you want to express the character's inner conflict or a sense of mystery.

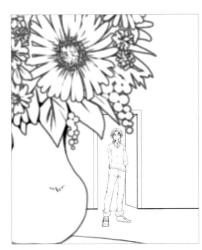

Although the vase placed in the immediate foreground, dominating the canvas, the viewer's gaze naturally falls on the character standing in front of the doorway.

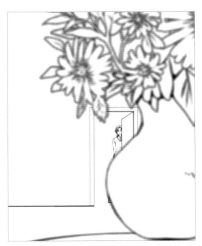

A character is peeking from beyond a doorway. In this example, the focus of the illustration is the situation inside the room. It forces the viewer to imagine what's going on unseen inside the room.

(Tips and Tricks)
Overlapping

To arrange various motifs in an attractive layout, overlapping (layering objects) is effective. Many things we see in everyday life have parts that are obscured or overlapped by other objects. If you intentionally use this "overlap" in illustrations, you can hide parts of secondary characters or bring the main character to the forefront, thereby directly expressing the intent of the illustration.

Depth and Reality

How can we depict realism in an illustration? The key lies in the "depth" apparent on the canvas. I'll explain this point by incorporating perspective and other techniques.

Representing a Three-Dimensional World on a Two-Dimensional Canvas

One of the vital elements in drawing illustrations is conveying a sense of presence or realism. To give viewers the impression that the world within the illustration truly exists, it is essential to evoke a sense of "depth." That means representing the distance between things that are far and those that are near, and creating a three-dimensional spatial sense within the canvas. Illustrations without depth cues feel flat and differ from the world we live in every day. Particularly for fantasy illustrations set in imaginary worlds, it's vital to be aware of depth to express their sense of presence.

There are various methods to evoke depth on the canvas or to represent a three-dimensional world in a two-dimensional panel. For instance, leveraging the overlap of characters or objects, being conscious of the foreground (close-up), midground (middle) and background (distance) while drawing. There's also the perspective technique where characters or backgrounds are drawn smaller the farther away they are. Objects nearby are drawn boldly, but as they get farther away, colors become fainter and lines thinner—this is known as "atmospheric perspective." Moreover, being conscious of depth in the vertical and horizontal axes is crucial.

The depth axis is represented by diagonal lines that converge at a vanishing point, such as roads and rooftops stretching into the distance or the diminishing width of building facades. Another method is to create contrasts by having bright and dark areas within the canvas. Master the various techniques, and then use them differently based on the artwork, or combine them.

■ Foreground, Midground, Background

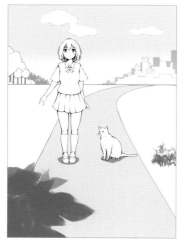

When considering a character as being in the midground, objects in front of them are in the foreground, and those behind are in the background. Representing the distance between these objects can express depth.

■ Atmospheric Perspective

Atmospheric perspective is a technique that utilizes the real-world phenomenon where distant objects appear desaturated and hazy due to the scattering of light by atmospheric moisture, making their outlines indistinct.

■ Depth Axis

Being aware of the depth axis when drawing can evoke a sense of three-dimensionality and realism in the panel.

The Impression Changes Based on Arrangement

Consider methods of expressing depth using superimposition (overlap) and perspective. By rearranging four elements—a character, a cat, a house and a tree—within the image, the impression can vary.

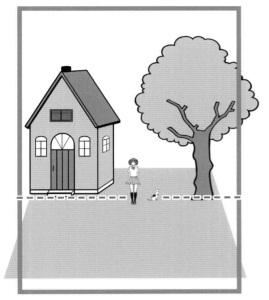

With all four elements arranged side by side, the illustration doesn't express the spatial depth.

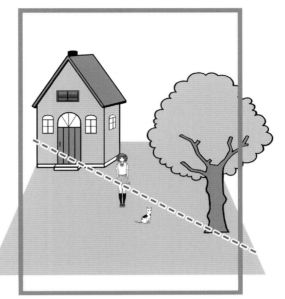

By changing the arrangement to foreground and background, adjusting sizes according to perspective, the sequence remains straightforward and dull.

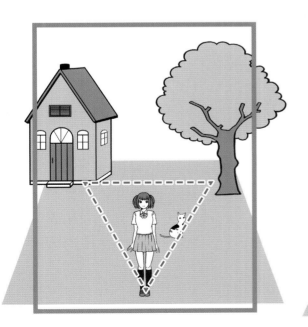

Elements arranged in a triangular configuration seem isolated and disconnected, giving an unstable impression.

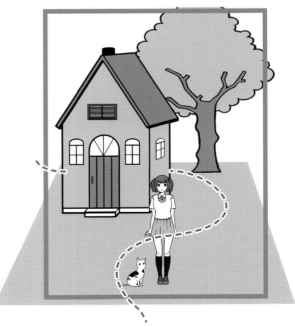

Expressing depth by superimposing elements: the lines of the branches and roof guide one's eyes to the character, suggesting flow.

Guiding the Viewer's Gaze to the Main Character

By creating guiding "lines" on the canvas, you can emphasize the main character. Be mindful of the flow of these lines when positioning motifs.

The Main Character Should Always be in Focus

When considering a composition to emphasize the main character, a crucial point is controlling the path of the viewer's gaze. If you draw without awareness, accidental lines created by the placement of elements can divert the viewer's attention away from the intended focus or even out of the frame. When drawing an illustration, always be conscious of the primary element you want to showcase in your artwork.

The drawing below indicates the movement of the viewer's gaze with arrows. Make sure the lines created by the elements flow rhythmically and without interruption. Depending on the scene, intersecting several lines can enhance dynamism or tension. Imagine the path of the viewer's gaze as you work.

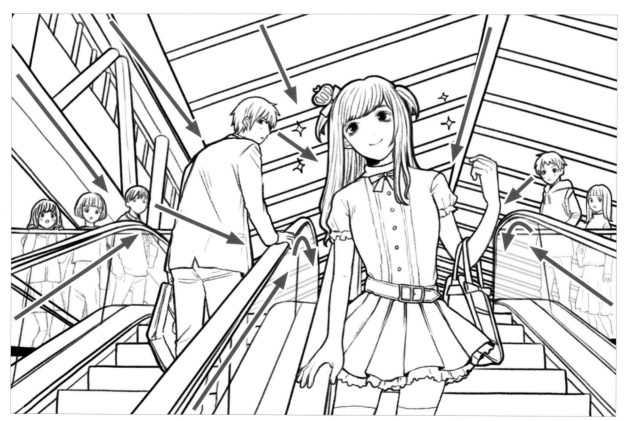

Lines formed by escalator handrails and architectural features lead to the main female character, drawing attention. A key point to note is how the lines of the handrails, even when initially directing the gaze toward other characters, ultimately curve to lead back to the main character.

The Flow of Lines Creates Rhythm

Position human characters, UFOs, robots, trees, mountains, etc., on the workspace to create the flow of the viewer's gaze. Not only straight lines, but curved lines can also give a dynamic rhythm.

Prevent the lines directing the viewer's gaze from crossing between the background and the main character where they may become too cluttered, or too linear, lacking movement and rhythm. Design while considering the effective flow of lines.

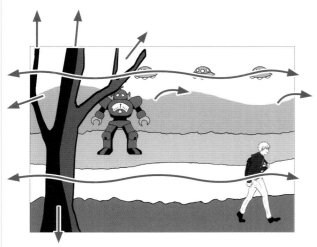

An example of a suboptimal design: The lines created by mountains, roads, trees, the path of the protagonist's travel, etc., point outside of the frame. The line on the robot's shoulder superimpose the mountain ridge. The scenario appears unnatural, and the artist's intent isn't clear.

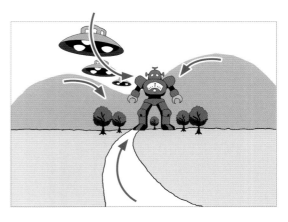

In another example, the lines from the series of UFOs, mountain ridges and road converge like focal lines toward the main robot character, showing what the artist wants to highlight. However, it may lack intrigue because it's too straightforward.

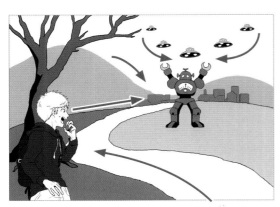

In an example of good composition, a line entering from the bottom right encounters a human figure, and together with the human's gaze, shifts to what the artist wants to show (the robot). The redirected flow of lines creates movement on the canvas.

(Tips and Tricks)

The Z and F Principles

It's said that human eyes move in a Z pattern when looking at printed materials or convenience store shelves. This is called the "Z principle" for eye movement. Websites, on the other hand, tend to follow an F pattern, known as the "F principle." In both cases, the first place the eyes go to is the top left of the image. Placing essential elements here can be effective.

Using Shapes in Composition

A common hidden element in many pictures that gives a sense of stability is a certain subtle geometric silhouette that subconsciously appeals to our eyes. This composition technique has been consistently used in artistic expressions since ancient times.

Which Shapes Do People Prefer?

Which shapes do people find appealing when they see them? This was studied in the field of psychophysics by a German physicist named Gustav Fechner. He conducted an experiment where he showed a variety of shapes to a randomly selected group of people and asked, "Which one feels most comforting and calming?" and "Which one do you prefer?" The rankings based on the votes were as follows:

1. Geometric and artificial shapes based on rectangles, circles, isosceles triangles, and right-angle triangles.
2. Shapes of natural objects like butterflies, leaves, human hands, and heads.
3. Odd or abstract shapes.

From this experiment, it was determined that people feel comfortable with simple geometric shapes. This aligns with the styles of compositions used in paintings from ancient to modern times, such as rectangular, triangular and elliptical compositions.

The popular shapes in Gustav Fechner's experiment were familiar ones like circles, triangles and rectangles.

Rectangular Composition

Many art surfaces (paper, canvas, artboard) are rectangular, which is one reason why I like this composition. In Egyptian, Greek and Gothic art, the rectangular composition based on the golden ratio is used as the standard. There are cases where one rectangle is used and cases where multiple rectangles are used, but both are fundamental composition methods for painting. Rectangular compositions also appear in bisected compositions, vertical line compositions, horizontal line compositions, golden ratio compositions and silver ratio compositions.

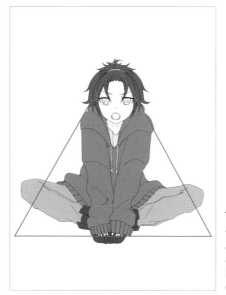

Triangular Composition

The equilateral triangle and regular triangle composition is a traditional composition with elements of symmetry, also known as the "pyramid composition." It has been consistently used in portraits since the Renaissance. By shifting the triangle from the center of the canvas, tilting it, or using multiple triangles, you can create unexpectedly interesting effects.

Oval Composition

This is a relatively new composition method believed to have been used in Europe starting around the end of the eighteenth century. It is said to have been conceived to introduce freedom into compositions, providing liberation from the constraints of classical composition based on rectangular and triangular compositions. Derivatives include the curved line composition, the S-shaped composition, the framing-tunnel composition and the curve vs. straight contrast composition, which are still used in many illustrations today.

Right Triangle Composition

This composition has been favored by painters since ancient times. The typical characteristic is that the triangle is incorporated into the image in a way that is not immediately obvious. The right triangle is also included in diagonal compositions and oblique compositions.

■ **L-Shaped Composition**

■ **J-Shaped Composition**

Letter Compositions

The forms of letters such as C, J, L, M, S, T and Z are combinations of rectangles, circles and triangles. Moreover, because we are accustomed to seeing letters on a daily basis, we feel a sense of familiarity when viewing illustrations using this type of composition. Artists from all around the world and throughout history have incorporated them into their work, perhaps unintentionally. In particular, the L-shape can be seen in many artworks across the eras.

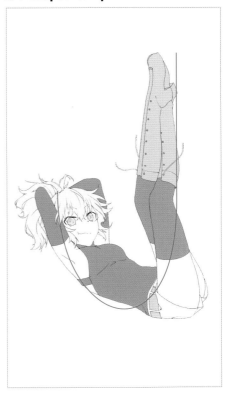

Consistency and Variation

For a cohesive image, consistency is necessary. However, just that alone can be rather boring. Hence, the need for contrast and variation, but care must be taken not to go overboard.

Creating Interest with Variation

A final image needs cohesion. Cohesion is balance and unity. And, while maintaining this unity, the intrigue and allure of the image are created through contrasts and changes. These variations emerge by changing up motif size, shape, position and intervals.

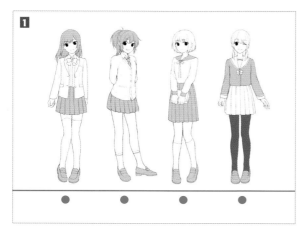

Imagine characters of similar appearance lined up side by side. There's cohesion, but because of its monotonous repetition, there's no drama, and it isn't an engaging composition.

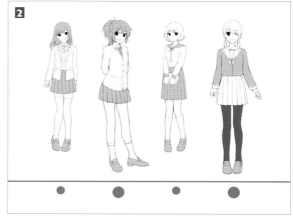

By simply changing the size of two characters, immediate variation occurs. It's a simple change, but it results in a more attention-grabbing composition than the repetitive arrangement.

Furthermore, by altering each of their sizes and introducing variations in spacing and arrangement, relationships between characters can now be imagined.

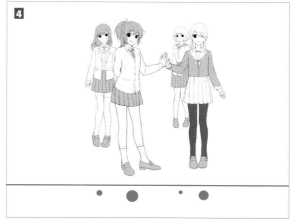

Overlapping parts of the characters makes changes in size and spacing more apparent. The image becomes dramatic and captivating.

Being Aware of Contrast

In illustrating backgrounds, repetitive elements can often come across as being dull. Monotonous patterns, like repetitive waves, don't retain viewer interest for long (though, as an exception, large repetitions can create patterns and work effectively, see page 25). By changing elements like size, form, position and spacing, irregular wave patterns can be created that capture the viewer's interest.

■ **Monotonous Arrangement**

Imagine arranging the same-shaped houses, trees and clouds. Like repetitious flat waves, it doesn't capture viewer interest.

■ **Varied Arrangement**

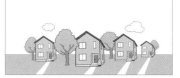

By changing the size and arrangement of elements and using superimposition, the contrast in the image shifts dramatically, generating interest.

Finding Your Balance

What would happen if you introduced extreme differences in sizes or shapes to create greater variation? For instance, if you were to draw diverse characters like monsters and fairies, only keeping their outfits relatively common (see the drawing to the right). While it might depict a whimsical, wild story, the overall piece lacks cohesion and can fatigue the viewer.

Complexity necessary to engage the viewer is essential, but it shouldn't be so complex that it confuses and exasperates them. In other words, a good balance of unity and variation is needed. To achieve this balance, it's important to understand various compositions.

If the balance in a composition is too perfect, it feels stiff. However, if it's too imbalanced, it feels unfinished. As you draw more, find your unique balance point. This will project the individuality of your illustrations.

An example of extreme variation in characters, using only the outfits as a common point. The image gives a disjointed impression.

In contrast, characters with moderate variations provide a structure that feels unified yet varied.

Superimposing the characters as one unified group provides a sense of unity, and arranging them in 3D space introduces dimensionality and variation.

Balance of Canvas Size and Space

This section explains how to determine the size of an illustration and the numbers for "ratios" that appeal to viewers. Let's delve into achieving a balanced composition.

Is Our Usual Outlook Landscape-Oriented?

When starting to draw an illustration, the first things to determine are the size and shape of the canvas. In particular, choosing between landscape (horizontal) and portrait (vertical) orientation is an essential step. If it's a picture of a character standing, then it's usually portrait, and if they're lying down, it's landscape. However, while it's tempting to decide based solely on the subject's presented shape, there are important distinctions between landscape and portrait presentations, and the choice between the two should match the artwork's theme and purpose. But before we discuss that, let's consider the human "field of vision."

The field of vision is the range we can see without moving our heads. When humans casually look ahead, the view spreads horizontally. It's harder to see above or below without tilting our heads. The binocular field of view is about 200 degrees horizontally and about 130 degrees vertically. This means we usually see a landscape-oriented world.

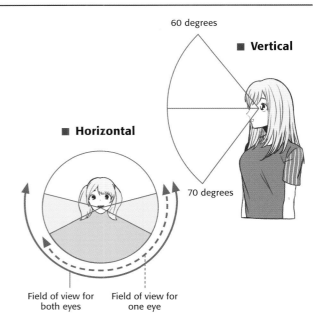

Field of view for both eyes Field of view for one eye

The horizontal field of view for one eye extends about 60 degrees inward (toward the nose) and between 90 to 100 degrees outward. Combined, both eyes produce an approximately 200-degree field of view. Vertically, the field extends about 60 degrees upward and 70 degrees downward.

Choosing Between Landscape and Portrait Orientation

Landscape orientation gives a sense of familiarity and stability because it resembles our usual view. When you want an objective view or to express vastness and stability, choose landscape. Because it stretches horizontally, height isn't emphasized in this orientation.

In portrait orientation, you can fit more on the canvas vertically, emphasizing depth or height. The viewer's focus doesn't scatter horizontally, making it suitable for highlighting the main character or theme. It's a composition where you can easily portray a close-up of the subject. It can also give a sense of confinement, instability or inhibition, as if you are restricting part of the viewer's vision.

Trimming a single illustration in both portrait and landscape orientations. Each gives a different impression.

Understanding the Golden Ratio and the Silver Ratio

The basic requirement of a good composition is to make viewers feel satisfied. This is achieved when the shape of the canvas is balanced. This balance, when expressed as a ratio, is known as either the "golden ratio" or the "silver ratio." Both originate from the idea that a canvas defined by a particular ratio appears harmonious and familiar.

The golden ratio, also referred to as the "divine ratio," is evident in Western historical architecture and art. Since the time of Leonardo da Vinci, who identified this ratio in ancient artworks, painters, architects and designers have intentionally incorporated the golden ratio into their masterpieces. It can be seen everywhere from the Pyramids and the Parthenon to the *Mona Lisa* and modern corporate logos.

The silver ratio is said to feel familiar and calming. This ratio, also known as the "Yamato ratio," is commonly used in old Japanese buildings. Paper sizes like those in the "A series" and "B series" actually have the same ratio between their short and long sides. When the short side is 1, the long side is $\sqrt{2}$ (1.4142...), utilizing the silver ratio.

The ratio between the short and long sides of a rectangular canvas is called the "aspect ratio." For instance, A-series aspect ratio = 1:$\sqrt{2}$ (about 5:7).

■ **Golden Ratio**

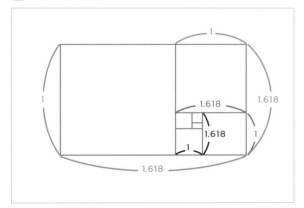

Approximately a 1:1.618 (about 5:8) ratio.

■ **Silver Ratio**

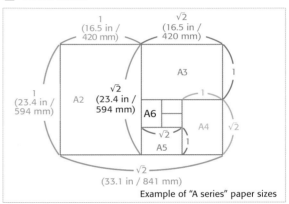

Example of "A series" paper sizes

A 1:$\sqrt{2}$ (about 5:7) ratio.

(Tips and Tricks)

Beauty or Cuteness?

The human body's proportions perceived as most beautiful follow the golden ratio: from the top of the head to the navel is 1, and from the navel to the heels is 1.618. This is suitable for drawing elegant characters. On the other hand, the comforting silver ratio can be utilized for drawing cute characters like chibis.

■ Golden Ratio Character Image: Adult, sexy, powerful, cool, realistic.

■ Silver Ratio Character Image: Child, cute, comical, friendly, cheerful, active.

■ **Golden Ratio:** Elegance

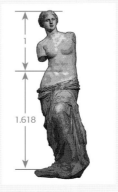

■ **Silver Ratio:** Cuteness

Creating a Well-Balanced Canvas Division

Both the golden ratio and the silver ratio can be applied not only to aspect ratios but also to dividing the canvas and arranging elements such as characters. These are referred to as "golden ratio division" and "silver ratio division."

The figures below divide the expanse of the sky and the sea (or ground) using both the golden ratio division and the silver ratio division. In this instance, the dividing line separating the sky and the sea becomes the horizon. Beyond just partitioning the space using these divisions like this, one can also position elements directly on the dividing line or at its intersections.

There's also a compositional technique similar to this called the "rule of thirds," often used in photography. The rule of thirds involves dividing the frame vertically and horizontally into nine equal parts. Essential elements are then placed along these lines or at their intersections.

■ Golden Ratio Division

■ Silver Ratio Division

When you place the dividing horizontal line closer to the bottom of the frame, you get a larger portion of the sky, and when it's closer to the top, you have a smaller portion of the sky.

■ Rule of Thirds

When you're drawing several elements, these techniques can serve as a guideline to avoid making the composition appear too disorganized. They're also useful when dividing spaces.

■ Halving

There's also a "halving composition" where the workspace is divided equally into two. This composition often appears very static, but depending on the subject matter, it can be the most fitting choice.

(Tips and Tricks)
Using Division Lines as a Guide

Positioning elements on the dividing lines or their intersections in the golden ratio provides a sense of stability to the composition.

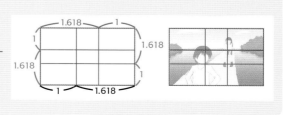

The Division Line is Just a Guideline

When drawing illustrations, it's not necessarily the case that you must strictly adhere to the golden ratio or the rule of thirds. Think of these as mere guidelines. Use them when you're unsure about decisions like "where to place multiple characters on the canvas" or "where to draw the horizon."

If you draw division lines at the outset, the joy of creating a work from scratch can be diminished. So, it's essential to first try different compositions through trial and error.

The red lines represent the rule of thirds composition.
The green lines represent the golden ratio division composition.

If you're undecided about using the golden ratio or the rule of thirds when dividing the workspace, try drawing reference lines for both. There's no need to strictly follow one or the other. Rearrange and place the elements while considering both.

Patterns to Avoid—and Exceptions

Both the golden ratio and the rule of thirds have 4 dividing lines and 4 intersection points. The effect can vary significantly depending on where elements are placed. While it's hard to generalize due to factors like the direction, shape, size of the elements and their relationship with the background, there are certain compositional patterns that are better avoided.

However, you can use these patterns to your advantage, producing feelings of unease or adding a rhythmic impression to a regular arrangement. After learning the basics of composition, intentionally choosing unusual applications can lead to originality. It's crucial to familiarize yourself with various compositional alternatives.

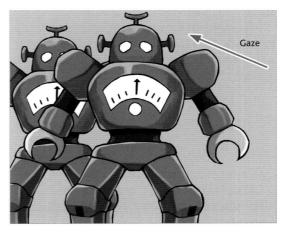

When there's no empty space along the path of the gaze, it can generate a feeling of oppressiveness.

Elements placed at the top of the canvas that give a heavy impression can induce feelings of unease. This is because humans have an innate understanding of gravity and an unconscious expectation that objects fall downward.

Things arranged neatly and regularly convey a sense of stability—but can also tend to become monotonous.

Using Symmetry in Your Compositions

Balanced symmetry is a fundamental composition technique that one should master. Not limited to mere left-right symmetry, there are various types of symmetry, each delivering a unique impression to the observer.

What is Symmetry?

In general, illustrations can be categorized into two types: symmetrical compositions and asymmetrical compositions. "Symmetry" implies that based on a central axis or point, elements in an illustration are identically arranged either on the left and right or top and bottom.

The central axis or point may or may not be drawn. One familiar example is having a main character in the center with supporting characters placed on both sides.

The human body is generally symmetrical along the midline that extends from the top of the head down to the feet.

Types of Symmetry

"Symmetry" is commonly assumed to refer to "bilateral symmetry," but there are also other types of symmetry such as "rotational symmetry," "translation" and "scaling."

Bilateral Symmetry (Linear Symmetry, Reflection, Mirror Image)

This is the most familiar form of symmetry. Various designs—from churches, temples and palaces, to paintings and sculptures—have incorporated this symmetry. Especially prevalent in Western architectural design, it conjures impressions of dignity, tradition and opulence. Mirroring one half of an illustration is termed a "mirror image," evoking the enchantment of stepping into a mirrored realm.

■ **Examples of Bilateral Symmetry**

Structures like the Palace of Versailles and the Louvre Museum epitomize symmetry.

The combination of bilaterally symmetrical composition with triangular composition is one of the most stable forms in art.

Rotational Symmetry & Point Symmetry

Rotational symmetry involves rotating shapes around a central point. It doesn't possess the grand stability of left-right symmetry, but it looks dynamic.

Point symmetry places elements equidistantly opposite a central point. Consequently, a 180° rotational symmetry becomes point symmetry.

Translational Symmetry

Translational Symmetry involves arranging identical shapes in parallel. This pattern expresses rhythm and dynamic harmony. Examples are seen in train or airplane windows, stairs, lattice doors, railroad ties, building windows, housing blocks, tiled floors and brick walls.

Scale Symmetry

Scale symmetry comprises enlarging or shrinking the same shape progressively in series. The progression conveys evolution and growth, marrying stability with variation.

Symmetry is widely used in designs we see everyday, such as buildings, furniture, electronic products, ornaments, company logos, etc. In psychology, there's the term "symmetry effect," denoting the positive attributes like beauty, reliability and authenticity that we associate with symmetrical objects. Symmetry is rare in nature, thus esteemed and sought after. Studies have concluded that individuals with more symmetrical appearances are more attractive to survey respondents.

Regular symmetry evokes harmony and calm. It makes for a straightforward composition, and is easily employed even by novices. However, its inherent monotony can become tedious when regularly used. When incorporating symmetry, always add variation to keep things interesting.

■ **Rotational Symmetry**

The recycling logo uses rotational symmetry.

■ **Point Symmetry**

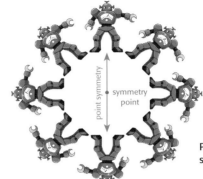

Point symmetry combines stability with rhythm.

■ **Translational Symmetry**

Humans perceive continuity when the same shape is arranged at the same interval five times or more.

■ **Scale Symmetry**

Gradually increasing sizes conveys evolution and growth.

The depiction of scattered stars in illustrations is also a form of scale symmetry.

Tips for Using Asymmetry

While you should be familiar with symmetry, it's equally crucial to understand asymmetry in compositions. Using asymmetry can add dynamism to a frame, though mastering it requires some finesse.

Controlling the Weight of the Frame

While symmetric compositions provide stability, they can often come across as too stiff and lacking in interesting arrangement (Figure 1). That's where free-form asymmetry comes in handy. However, it's essential to plan the placement thoughtfully; otherwise, the balance could easily be thrown off (Figure 2). Key to balancing an asymmetric composition is ensuring that the perceived "weight" on either side of the frame is even (Figures 3 & 4). Various factors can influence this "weight," such as the size of the motifs or their distance from the central axis (Figures 5–8).

One particularly crucial factor is the "weight of presence." The significance or attention a subject demands within the frame can impact its perceived weight (Figure 9). For instance, a main character holds substantial importance, thus requiring appropriate weight. Even if the character is small, it should be portrayed in such a way as to grab attention.

Figure 10 showcases how to adjust the balance from the scenario in Figure 2. When illustrating, always be conscious of the "weight" of each element, striving for a well-balanced frame.

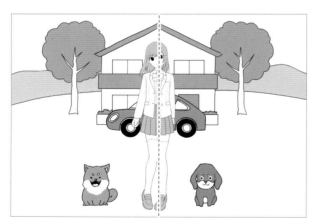

(Figure 1) A symmetric composition. It has stability but feels rigid and lacks motion. Both sides possess equal weight, creating equilibrium.

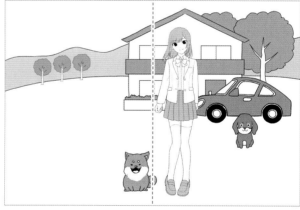

(Figure 2) An asymmetric composition. Because the motif is positioned more to the right, the canvas seems stretched out. The right side is heavy, making it imbalanced.

(Figure 3) Symmetric situation. If two individuals of the same weight sit on a seesaw equidistant from the fulcrum, it balances out.

(Figure 4) If two people of different weights sit on a seesaw, balance is achieved when the heavier person moves closer to the fulcrum and the lighter one moves away.

(Figure 5) The perceived weight changes depending on the size of the motif.

(Figure 6) Increasing the number and grouping of multiple motifs together can make the composition feel heavier.

(Figure 7) Even if they're the same size, objects with implied greater mass appear heavier. For example, between cotton candy and an iron ball, the iron ball looks heavier.

(Figure 8) Objects of the same weight feel heavier when placed near the edge of the frame. The principle of the seesaw (Figures 3–4) applies here as well.

(Figure 9) Wouldn't the weight of presence felt between a photo of a stranger and a signed photograph of your favorite idol be different? This too is a form of weight.

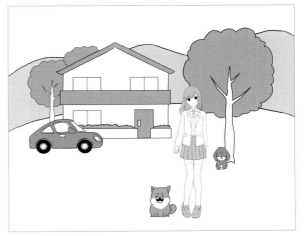

(Figure 10) An adjusted version of Figure 2, considering the weight in the frame. It achieves both contrast and stability.

Understanding the Effects of Color

The effect of color in composition plays an equally vital role as the panel shape, apparent depth, lines and so on. In particular, the brightness of color greatly affects the image and atmosphere of the work.

Three Attributes of Color

Colors exhibit three attributes: hue, saturation and brightness, together referred to as the "three attributes of color." Hue refers to color tones such as red, yellow, blue and purple. Groups with a strong red undertone are termed "warm colors," and those with a blue undertone are termed "cool colors."

Saturation pertains to the intensity or vividness of a color. High saturation results in a clear and vivid color, while low saturation results in a muted and subdued color. White, gray and black don't contain any color tone, hence they have zero saturation and are called "achromatic colors." Conversely, the colors with the highest saturation are termed "pure colors."

Brightness measures the lightness of a color. The higher the value, the brighter the color. Achromatic colors only possess brightness. Depending on its brightness, the perception of a color's weight, hardness, expansion or contraction can change. Brightness is a particularly important attribute when considering the balance of a composition. For example, a cheerful scene might feature high brightness colors, while a scene with a sad character could utilize lower brightness colors. Scenes of battle or shocking events can benefit from strong contrasts in brightness.

■ Hue

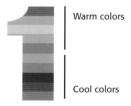
Warm colors
Cool colors

"Hue" is the term used to distinguish different color tones.

Advancing colors

Receding colors

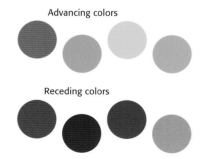

Warm colors appear to advance, or "pop out," and cool colors seem to recede or "fade into the background." Leveraging this characteristic can help control depth perception and differentiate between prominent and less noticeable colors.

■ Saturation

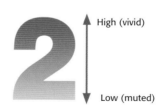
High (vivid)
Low (muted)

Saturation is a metric that represents the vividness or intensity of a color. As saturation increases, it approaches pure color, and as it decreases, it approaches achromatic colors.

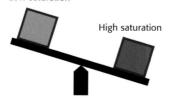
Low saturation
High saturation

High saturation feels heavier. When striking a balance in composition, it's beneficial to intentionally adjust saturation.

■ Brightness

High (bright)
Low (dark)

Adding white to a pure color makes it "high key" (light-toned), and adding black makes it "low key" (dark-toned).

High brightness
Low brightness

Lower brightness feels heavier. It's essential to be conscious of brightness, particularly when working with achromatic colors or creating monochrome illustrations.

Influence from Surrounding Colors

Colors are influenced by the colors around them. When creating a piece of work, instead of merely progressing with the details, one should constantly check the overall color balance as they proceed. This is because the way a color appears can change depending on the colors adjacent to it. When colors are arranged in a mutually complementary way, the result is a beautifully balanced and vivid display.

When placing yellow on a white background and yellow on a black background, the impressions are clearly different. The same optical illusion occurs with gray; gray on a white background appears darker, while gray on a black background appears brighter. By applying this principle to your illustrations, you can emphasize or downplay certain parts of an image.

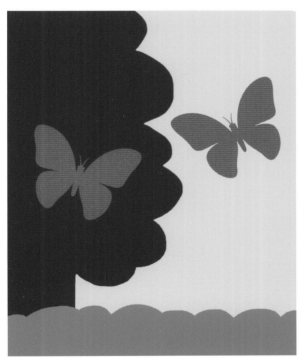

Two butterflies are drawn with the same shade of red. However, the red placed over a dark green background appears brighter than the red placed over yellow to most viewers.

The three trees shown here might seem to exhibit different hue, saturation and brightness, but they are all the same color.

(Tips and Tricks)

Drawing an Illustration = Adjusting the Balance of the Three Color Attributes

When placing a color on a white canvas, starting with the shadowed parts might make these elements seem too dark. However, as you continue to draw and apply other colors, the intensity of the shadows diminish and gradually become incorporated naturally into the image. This illusion of "changing brightness" is something illustrators must be acutely aware of. By drawing numerous illustrations and accumulating experience, one can predict the mutual influences colors can have on one another. Drawing an illustration can be described as a task where you constantly adjust the balance between hue, brightness and saturation.

Guiding the Viewer's Gaze with Differences in Brightness

When constructing an illustration by combining various motifs, you control the difference in brightness of each element, considering what you want to highlight as the main focus.

The illustrations below demonstrate the control of brightness. By adjusting the contrast of light and dark between simple shapes of objects and their backgrounds, what is emphasized changes.

The bowl, bottle and lemon are drawn in similar tones with the background, lacking in contrast.

The brightness of the bowl, bottle and background has been reduced. The viewer's gaze is drawn to the lemon, which is brighter in comparison.

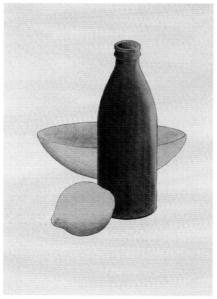

The background brightness is increased and the bottle's brightness is decreased. The contrast between the two is stronger, making the bottle stand out.

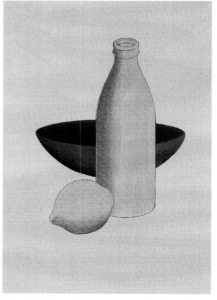

To guide the viewer's gaze to the bowl, its brightness has been reduced, clearly differentiating it from the motifs in the foreground.

Adjusting the Overall Brightness of the Image

The contrast in brightness becomes more critical in artworks with intricate elements. Because the difference in brightness can be hard to discern amidst hue, saturation, shape of the elements and texture, it's a good idea to grasp the general light-dark balance in a monochrome state before coloring. When drawing with digital art software, you can check the balance of brightness by changing the color mode to grayscale.

Furthermore, even after the coloring process is complete, recheck and correct the brightness to ensure it's appropriate for the theme of the artwork. The impression of a piece can greatly change based on brightness differences.

Rich colors are born when colors within the artwork complement each other. Embrace the basics of color, draw fearlessly, and craft your unique color harmony.

Ascertain the balance of brightness in grayscale mode. In this illustration, due to the contrast in brightness, it's clear what the artist wants to highlight. It skillfully uses the brightness of the character's face, the whiteness of the pages of the book and the contrast between light and shadow.

■ **Dark tone (Low-Key)**

■ **Medium tone (Middle-Key)**

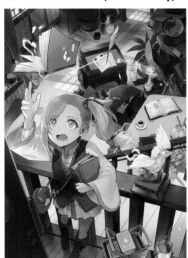

■ **Bright tone (High-Key)**

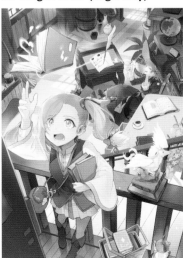

Good Compositions Come Afterward?

Professional illustrators don't often start with a fixed compositional method when drawing. In Chapter 3, "Composition Examples," only a few of the selected illustrations were specifically drawn to fit a certain composition method. Most of them were first identified as original and compelling pieces, and then they were analyzed to see which compositional method category they fit into.

One difference between professional and amateur illustrators is said to be the quality of their composition. Artworks that are deemed "good" often fit into compositional methods that have been adopted in the art world since ancient times.

However, this does not mean that professional illustrators are innately attuned to these compositional methods. They have studied to develop a firm grasp of the basic principles of composition. Through trial and error, as they create many illustrations, they adopt various compositional methods that suit their style and technique.

As you continue to create more artwork, you too will find compositions that fit your style. When that time comes, referring to the compositional methods introduced in this book can effectively help you understand and construct your compositions.

First, understand various compositional methods and try drawing pieces according to them. Instead of being satisfied with mundane compositions or repeatedly using the same one, always challenge yourself with new compositions.

The two illustrations on this page were created by an illustrator who studied in the class I attended at a specialized school and who is now working as a professional. They didn't start by using a prescribed compositional method, but drew while thinking about how to make the most of their desired ideas and themes. The results coincidentally fit into the "Golden Ratio Division Composition" (page 68) and "Central Circle Composition" (page 76).

■ **Golden Ratio Composition**

■ **Circular Composition**

Artist: 橋本あやな

Characters and Composition

Drawing vivid characters is one of the true pleasures of illustration and manga expression. Here, you'll learn about framing and posing to make their presence stand out within the composition. I also introduce variations of placements based on the number of characters, which can serve as a significant hint when considering which type of composition to use.

Differences Between Characters and Objects

Characters differ from objects; they depict living beings that move of their own free will. When drawing people for dramatic illustrations, special consideration is required.

Understanding Characters Deeply

In any scene, the thing that draws the viewer's attention the most is the character. In many illustrations for games, publications and advertisements, characters play a crucial role. The principles of composition are basically the same, whether it's a character illustration or a still life. However, characters are fundamentally different from objects in the sense that they convey motion and a sense of vitality. Keep in mind that most characters change their form by moving. Also, when multiple characters appear, you must consider their relationships with each other. Illustrators need to fully understand the characters and situations they are trying to depict. By thinking carefully about the settings of the characters and drawing their expressions, poses and actions, the illustrator's role is to convey to the viewer who the character is, what they feel, what they think and what they are doing.

■ Meaning Arises from Poses

A lifeless mug is an "object" that cannot move on its own. On the other hand, even when a character (in this case, a person) is not moving, they convey a sense of life, and the slightest movement imbues them with meaning.

■ Stories Emerge from Relationships

While it's hard to create drama with multiple mugs, multiple characters interact with each other, creating drama. It is their relationship that creates the narrative.

The direction of the gaze is an important point in composition. A common example seen in game packaging and posters is the "camera gaze." With this, the viewer's gaze is drawn into the image. You often see compositions where the face is looking to the side or at an angle, but the eyes are directed at the camera.

When two characters appear, the way their gazes intersect can specifically convey their relationship. If they're looking at each other with a smile, it implies a friendly relationship, whereas if their eyebrows are raised and they're glaring, it suggests a hostile relationship. You can communicate with the viewer in this way.

For arrangements with three or more people, various patterns can be considered, such as "each looking in a different direction," "everyone looking in the same direction" and "only the main character looking at the camera, while the other characters are looking at the main character." Try expressing the relationships between the characters using their gazes in your own illustrations.

Expressing Emotions with the Entire Body

In character illustrations, posing greatly influences the composition. Here, we'll consider the relationship between emotions and actions.

Matching Emotions and Actions

Character emotions are particularly reflected in the facial expressions and hand movements. However, emotions, of course, are also reflected in the entire body. When creating character illustrations, it's important to draw the entire body with rich expressiveness as an element of the composition. Along with movements, the silhouette of the body changes in various ways, and the poses born from these movements evoke the character's mood and feelings. Poses such as jumping for joy and slumping in disappointment are examples where emotions and actions are closely intertwined.

In our everyday life, even in painful situations, we may deliberately behave cheerfully or assume a pose different from our feelings when our emotions are in turmoil. However, in the case of a single illustration, it's helpful to the viewer and less confusing if the actions and emotions are clearly linked. Of course, in manga or novel illustrations, the influence of the text description and the flow before and after allows for expressions where actions and emotions do not necessarily align.

There are five emotions depicted by lines. Linking each shape to the pose of the character can help express emotions.

■ Kindness, Tranquility, Sensuality

Flowing, soft curves express gentle and calm emotions. Straight lines and angular shapes are subdued.

■ Joy, Excitement, Vitality

Arms thrusting upward and the rising lines of the body transmit excitement and vitality outward. It's a pose full of energy.

■ Disappointment, Sadness, Regret

A hunched body and a drooping pose evoke feelings of sorrow, depression and fatigue.

■ Passion, Anger

This dynamic pose expresses explosive and energetic emotions. Angular, jagged lines create a sense of power.

■ Desire, Justice, Control

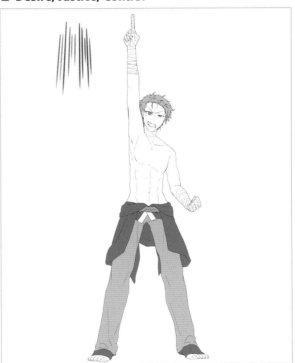

Standing vertically with an arm raised straight above and feet firmly planted on the ground represent upward aspirations and a sense of stability.

Contrapposto and S-Curve

How can you add variety to character poses that tend to become monotonous?
Let's learn the technique of contrapposto, which can be applied to any pose.

The Basics of Contrapposto

When drawing a character's standing pose, you'd usually want to avoid a perfectly upright pose unless there's a specific reason to use it. Even if you pay close attention to the composition of the illustration, the effect of the composition cannot be achieved if the character's pose is monotonous. However, adding a little variation to the standing pose can make it stand out dramatically.

One such technique is "contrapposto." Contrapposto is a term in visual arts that describes an asymmetrical pose where weight is placed on one foot, causing the body's center line to curve. In Western art, it has been used in sculptures, frescoes and paintings since before the Common Era. By placing weight on one foot, the position of the hip on the weight-bearing side rises, and to maintain balance, the shoulder drops. It's characteristic that the tilt of the character's shoulders and hips are in opposite directions. By utilizing this, you can express a smooth movement in the body's flow and a relaxed, beautiful body line. Try incorporating contrapposto in your dramatic character poses and alluring poses for female characters.

■ **Upright Pose**

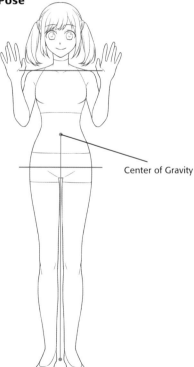

Center of Gravity

This is a bilaterally symmetrical upright pose with the center line as the axis. The center of gravity is in the middle of the body, and the weight is equally distributed to both feet, giving a sense of stability, but it lacks expression because it's static.

■ **Contrapposto**

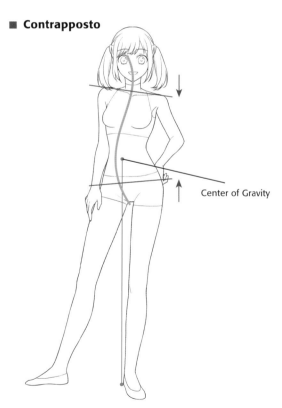

Center of Gravity

When a foot is shifted sideways, the weight is placed on the vertical leg. Now, in order to balance the body, the hip on the side where the weight is placed rises, and conversely, the shoulder drops, resulting in a supple and attractive body line.

Adding More Contrast with the S-Curve

A pose that further emphasizes the contrapposto, by curving the body line, is called the "S-Curve." In art terms, it is also sometimes referred to as the "S-shaped curve." The S-Curve in standing poses is emphasized more by greatly tilting the lines of the face, shoulders, waist, and knees. The contrapposto is a relaxed, natural pose, whereas the S-Curve can be described as a pose that expresses confidence, sexiness and dynamism.

■ **Contrapposto: Natural, Relaxed Pose**

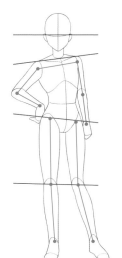

■ **S-Curve: Confidence, Sexiness, Dynamism**

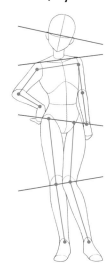

■ **Emphasizing the S-Curve**

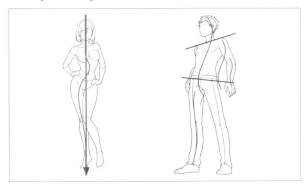

When the S-Curve is emphasized, for women, it brings out sexiness and dynamism. For men, puffing out their chest to emphasize the S-Curve in the torso gives an impression of confidence.

■ **Side, Diagonal, Back Poses**

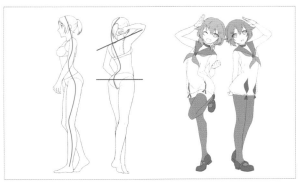

In female side or diagonal poses, emphasizing the supple line created by the S-Curve of the spine and hip line can make the body line more attractive.

■ **Sitting, Lying Down Poses**

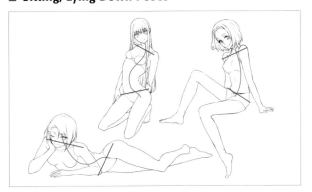

Sitting and prone poses are more relaxed postures compared to standing poses. Try to incorporate contrapposto to achieve a comfortable and natural-looking pose.

■ **Contrapposto and S-Curve in Motion**

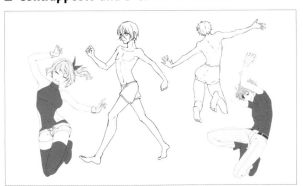

Even in poses with movement, being aware of the S-Curve greatly increases the power, elegance and dynamism of the figure. The S-Curve is created when there is a twist or flex in the torso. This is a particularly effective technique in battle scenes.

Framing Poses Using Shapes

When struggling with posing, such as when impactful poses don't come to mind, try fitting the entire silhouette of the body into a shape.

Triangular Framing

When you can't think of a character's pose or when they tend to end up in the same old pattern, try fitting the entire silhouette of the character into shapes used in compositions, such as triangles or circles. Triangles, which are used in standard compositions such as the triangular composition, go well with square canvases and create various changes, such as giving a sense of stability or creating movement, depending on their shape. There are various kinds of triangles you can fit a pose into. For instance, a stable triangle with its base down and an unstable inverted triangle, which give different impressions. Choose which one to use according to the character's personality and situation setting.

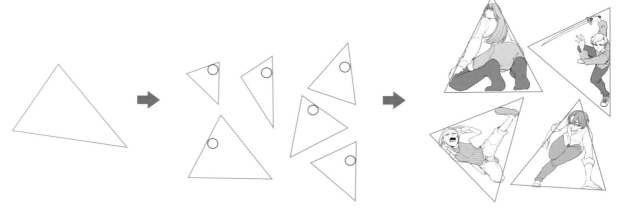

Draw a triangle. You can change the length and inclination of the sides later to fit the pose.

Decide the position of the character's head and sketch the figure. The position does not have to be at the vertex of the triangle.

Including outfits, hair, weapons and other items, draw so that the entire silhouette forms a triangle.

■ The Shape of the Triangle and Character Setting

■ Diamond Posing

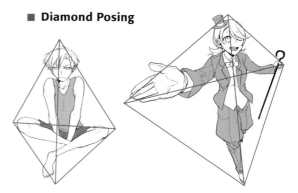

The upright triangle is suitable for character images and situation settings that are intended to evoke stability, trust, unity, etc.

Use the inverted triangle when you want to project the impression of instability, dynamism, speed, tension, etc.

The diamond shape (rhombus) is also a combination of triangles. The variation increases by fitting multiple triangles into the pose.

Circular Framing

A slightly advanced concept involves the shape of a circle. To include the full body, you might need to use low-angle or high-angle shots, or emphasize perspective. By mastering this method, unexpected poses can emerge, greatly expanding the variety of character poses. The impressions given by a circular frame include softness, harmony, introspection, calm and a sense of weightlessness. Try distinguishing its use from angular forms like triangles.

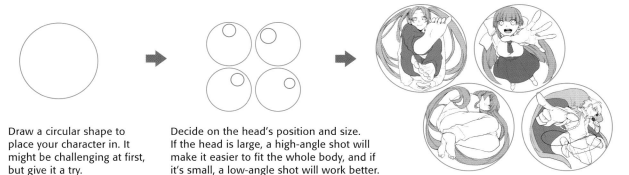

Draw a circular shape to place your character in. It might be challenging at first, but give it a try.

Decide on the head's position and size. If the head is large, a high-angle shot will make it easier to fit the whole body, and if it's small, a low-angle shot will work better.

Using circular framing, you can draw various impactful poses.

Other Shapes

Apart from triangles and circles, there are also poses framed by diagonal composition, poses overlaid on the golden spiral and methods that fit the shapes of alphabet letters. These can provide hints to expand variations when you're stuck with character posing. Experiment with various shapes and discover new poses.

■ Diagonal Line Posing

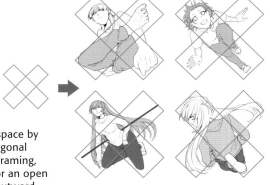

Create the impression of space by visualizing intersecting diagonal lines. Contrary to circular framing, this composition allows for an open movement that expands outward.

■ Golden Spiral Posing

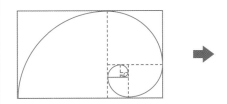

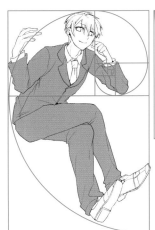

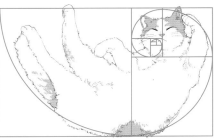

These are examples of posing characters in accordance with the golden spiral composition, which creates a beautiful and harmonious image.

Using Negative Space

For producing a sense of three-dimensionality, there's "exterior negative space," and for directing the viewer's gaze to areas of interest, there's "interior negative space." Being aware of these can help you create a more profound visual representation.

Exterior Negative Space Creates a Sense of Depth

In illustration, one must represent three-dimensional objects on a two-dimensional surface, such as paper or a computer screen. Three-dimensionality refers to a world with height (vertical), width (horizontal), and depth (the z axis: fore and aft). When attempting to represent this in two dimensions, the result often tends to appear flat. Moreover, when trying to depict overlapping objects, the distance between the motifs horizontally and in depth can be challenging to express convincingly.

To convey a sense of depth, one must first recognize the obvious fact that "for an object to exist, it requires space." This is the same principle as not being able to fit an item in a box if there isn't enough space for it. The space around a motif is called "exterior negative space" and is a vital element when planning a composition.

A sphere has depth (thickness) in three dimensions. Without expressing this through shading, it will only appear as a circle.

By visualizing the surrounding space as a box and placing a sphere within, you can recognize the depth it possesses.

These are four 3D shapes viewed from the front.

Be conscious of the space each form occupies. Even in a flat layout, by clearly depicting the fore and aft relationships, the sense of depth is enhanced.

When drawing characters, also be mindful of the space. Imagining both the form of the character and the three-dimensional space it occupies will help prevent a flat representation.

Guiding the Gaze with Gaps

Exterior negative space creates mood, atmosphere and memorable impressions in a scene, broadening the viewer's imagination and generating drama. In contrast to exterior negative space, interior negative space is created by a character's pose or gestures. Creating these gaps draws the viewer's attention, highlighting the character's form. Gaps are essential spaces within a scene that can intentionally emphasize the areas you want viewers to focus on.

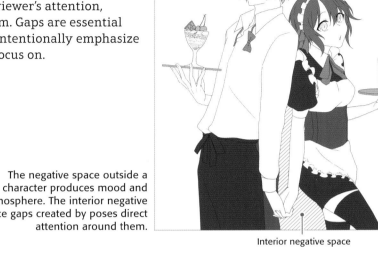

Exterior negative space

Interior negative space

The negative space outside a character produces mood and atmosphere. The interior negative space gaps created by poses direct attention around them.

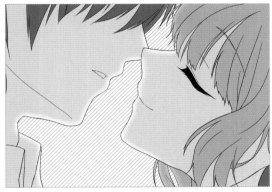

The form of the interior negative space, emphasized by using backlighting, makes the characters stand out.

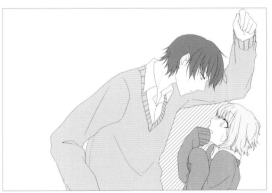

The interior negative space draws attention to the character's facial expression, making them more relatable.

The interior negative space between the legs emphasizes the beauty of the outlines.

The gaps created by the arms accentuate the body lines.

The gaps emphasize the face and chest.

Compositions with Different Numbers of People

Here, I introduce compositional patterns based on the number of characters. Please continue experimenting until you achieve the desired effect.

A Composition with One Character

When considering the composition for character illustrations, it's essential to carefully consider the number of characters, where they are placed on the canvas, and their size.

For a single character, decide on the size based on the situation. A close-up makes it easier for viewers to empathize, while drawing the entire body smaller allows for a more objective view of the character.

■ Differences in Impression Due to Size

A standing character has been placed prominently on the canvas. The character's presence dominates the frame.

The character has been drawn very small. The distance and isolation stand out, and the space overwhelms the character.

The character occupies most of the canvas, overpowering the space. Suitable for detailed depictions and emotional expression.

■ Close-up of the Face

A composition with a strong impact, making it easy for viewers to empathize.

When the character looks directly into the camera, emotions are conveyed straightforwardly.

A profile creates a sense of distance with the viewer. Suitable for expressing complex emotions.

A composition where half the face is cut off by the frame. It conveys duality, a sense of mystery, and sexiness.

■ Upper Body Shot

Considering a triangular pose often results in a more settled composition.

A frontal pose with the character looking into the camera. While there's no movement, it has a strong appeal.

Composition from a diagonal rear angle. The body's S-line guides the viewer's eyes to the face.

A composition cropped above the knee, forming an inverted triangle. It gives a feeling of bursting out of the frame.

■ Full Body Shot

Recommended when you want to showcase the character objectively.

A distant composition creates a sense of space between the character and the viewer, giving an objective impression.

A full-body shot of the character sitting on a stump. A triangle naturally forms, providing a sense of stability.

A full body back shot with the character looking away. It evokes various imagined narratives.

A Composition with Two Characters

Introducing two characters greatly expands the compositional variations. While constructing the composition, consider their relationship and individualities—are they allies, enemies, in a master-servant relationship, peers or romantically involved?

■ **Equality**

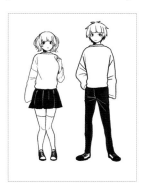

A side-by-side representation indicating a friendly relationship. Innovate with facial expressions and poses to avoid a mundane symmetrical composition.

A composition splitting the frame and showing half the face of each character. There are also variations where one side is inverted.

A face-to-face composition. The image changes dramatically based on their expressions, indicating hostility, romance, etc.

■ **Contrast**

Contrasting the main character with a rival. The top of the frame feels heavy, expressing tension and anxiety.

Expressing feelings toward the other character. The inverted triangular arrangement conveys a mix of anticipation and anxiety.

Drawing one character in a chibi style makes the relationship clear. Their depicted poses and expressions show contrast.

■ **Triangle**

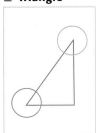

A common photographic composition of a standing and sitting two-person shot. The pair forms a triangle with their silhouettes.

Creating a triangular composition with close poses. Contrasting straight and curved lines of the male and female physiques.

Even within motion, be mindful to incorporate a triangular composition. An inverted triangle feels unstable but imparts a dynamic feel.

A Composition with Three Characters

When you have three characters, the relationships are more complex. Think about placements based on the backdrop of friendship, enmity or romance. You either depict all three characters as peers or focus on the main character, contrasting them against the other two. A variety of compositions can be considered, but using a triangular arrangement often makes it easier to fit the elements into the frame.

■ Equality

Three friends positioned side by side. Overlapping their bodies slightly expresses a sense of unity.

Divide the frame into thirds to clearly display each character's expression. Emotional expression is key.

Characters arranged front to back, but similarly scaled to keep a sense of equality. This example shows a combination of triangular and circular compositions.

■ Contrast

Two characters are in the front with one at the back. This forms a stable triangular composition.

Two characters are in conflict, observed by a third. An inverted triangle composition, expressing tension and anxiety.

Two characters are drawn up close with one depicted smaller. This evokes strong determination and impact.

■ Triangle

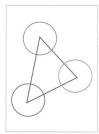

Though the three individuals are facing different directions, they are connected in an inverted triangle, expressing camaraderie and dynamism.

Arranging characters front to back adds depth to the triangular composition. An arrangement along an arc creates flow.

Contrasting front- and back-facing poses. Turning to look at the camera increases focus on the character in the foreground.

A Composition with Four or More Characters

With the introduction of four or more characters, you can have equal, contrasting types, or separate the main character from the others. Think symbolically about the overall relationships or group vs. group contrasts.

Characters framed side by side. Suitable for character introductions or showing different settings.

A V-shape arrangement to indicate depth. Stability is provided by radial cast shadows. Drawing from a slightly high angle allows the characters to fit comfortably into the frame.

One-point perspective used to emphasize depth. This arrangement exhibits a rhythmic mix of standing poses in a vertical, stable triangular composition.

Characters positioned in a circular arrangement, like forming a huddle. This composition indicates a strong sense of unity and allows for a clear view of facial expressions.

A composition tightly packed into a circular shape. Star-shaped compositions are another option. Contrasting main and sub-characters in size creates emphasis.

A hybrid of zigzag (Z shape) and triangular compositions. This arrangement exhibits harmonizing unity, depth perception and rhythm.

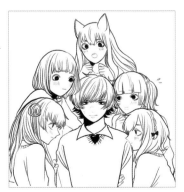

The main character contrasted against others in a triangular composition. Typically, an entourage or "harem-type" close-up composition.

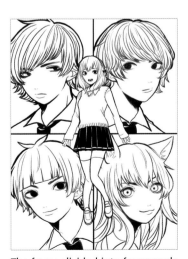

The frame divided into four panels featuring the sub-character's faces, with the main character prominently drawn in full in the foreground.

How to Crop the Image

Depending on how the image is cropped—whether it's the whole body, face or a bust shot—the impression given by the image can change significantly. Let's compare the effects of each presentation and see which type of scenes they're most suitable for.

Purpose-Specific Framing

The first step in determining the composition of a character illustration is to decide how to crop the character's body within the frame. The larger the character is to be featured on the canvas, the easier the illustration is to compose. Starting with a close-up and adjusting gradually while considering the balance with the background is one approach. The method of cropping will change depending on what you want to emphasize most, such as expression or posture.

The larger you draw the face, the clearer the expression becomes, while full-body shots are generally more descriptive, emphasizing the outfit, proportions and movement. Furthermore, the decision to draw in portrait or landscape is crucial. As the human body is vertically oriented when standing, portrait configuration—which can emphasize a character's presence by filling the vertical space—is customary. Even with full-body shots, portrait better balances the background. On the other hand, landscape orientation allows for more surrounding details to be included, providing an objective view of the character's relationship with the scene. Your choice will be determined by whether you want to zoom in on a character or showcase the entire scene.

Emotional expression in character illustrations is vital. Points to be careful about include facial expression, gaze, angle of the neck and pose. The angle of the neck can drastically change the impression. Also, if the details of the hands are drawn carelessly, it will be difficult for viewers to understand the drawing, so be meticulous with these details.

■ Full-Body (Full Shot)

This composition showcases the entire body. Avoid cutting off the head or feet and try to keep an equal amount of space at the top and bottom, or allow slightly more space above the head for better balance. The viewer's focus tends to be on the face, chest and waist, so ensure these areas are well-drawn.

■ Face (Close-up Framing)

Emphasizing facial expressions facilitates empathy toward the character. The eyes are crucial, and the direction of the gaze can change the story conveyed.

■ Bust-up Framing

This is one of the most basic compositions for character illustrations. The lines connecting the head and both shoulders form a triangle, providing stability. It doesn't suit exaggerated poses, but it is excellent for conveying emotion. A good balance is achieved when drawing the face above the midpoint.

■ Waist-up Framing

This is a half-body shot depicting the character from the head to the waist. It's the easiest shot to use to balance facial expressions and proportions. When in doubt about composition, a waist-up shot is a good starting point, and it also allows for a clear depiction of movement.

■ Knee-up Framing

This composition is close to a full-body shot, but it has a lighter feel because the feet aren't shown. It allows for the depiction of more dynamic poses, conveying a sense of style or allure. It's commonly used when multiple characters are walking side by side.

Unique Cropping

In addition to the aforementioned methods, there are other cropping techniques that emphasize a character's mystique or dynamism. Try placing paper over your drawn character to hide certain parts and see how the impression changes.

■ Cropping the Face and Feet

Conveys mystery, allure, duality and ruthlessness.

■ Cropping Both the Hands and the Feet

Recommended for when you want to emphasize dynamism, immediacy or intensity.

■ Cropping Part of a Body Posed at an Angle

This cropping style gives a sense of intimacy or makes a strong impact.

Perspective Drawing Techniques

When arranging multiple characters at varying distances, how can you accurately represent perspective? Let's look at two handy techniques.

Perspective Line Method

When placing multiple characters in a scene, you may be unsure about where and how large to draw each one. To make it look like multiple characters are standing naturally on the ground in a scene with depth, use perspective lines. This technique is called the "Perspective Line Method."

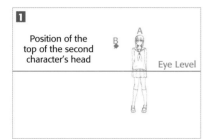

First, decide the size of the scene and draw Character A. Then, determine the position for the top of the head for the second character, B.

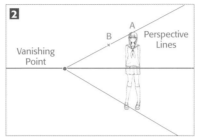

Draw perspective lines connecting the tops of the heads of characters A and B down to the horizon line (in this instance, the height of the waist). The point of intersection becomes the vanishing point. Draw perspective lines from their feet as well.

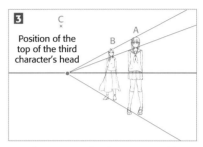

Use the perspective lines as a guide to draw the entire body of Character B. Next, decide the position for the top of the head for Character C.

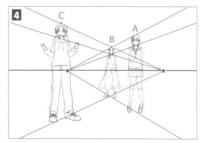

From the top of Character C's head, draw a perspective line through the top of the head of either Character A or B down to the horizon line. Determine the position of the feet using perspective lines, and then draw the entire body.

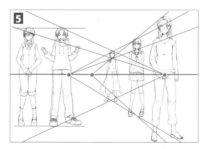

Even characters positioned outside the original frame can be drawn by extending the same perspective lines.

Eye Level Method

In addition to using perspective lines, there's also a method that involves drawing characters based on a consistent eye level. First, decide which part of the body's height you will use for the eye level. Then, place the same part of each character's body at that height in the scene, regardless of their distance from the viewer. This is called the "Eye Level Method."

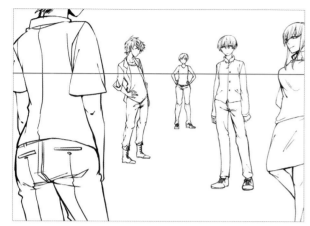

All characters positioned in the foreground, midground or background have their chests at eye level.

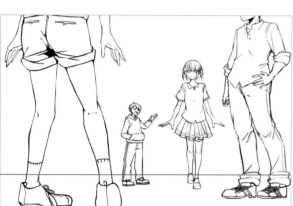

The eye level set at the height of the ankles. Using the Eye Level Method enables you to also depict low-angle shots. If the sizes of the characters seem off, it's a good idea to also use the Perspective Line Method to check.

Set the eye level at the characters' eye height. For characters of similar height, if you draw them so that the same part of their bodies aligns with the eye level, you can depict multiple characters without needing the guidance of perspective lines.

(Tips and Tricks)
Eye Level

Eye level refers to the "height of the viewpoint." Think of it as the height of a camera when taking a photo. In the illustration below, the eye level is at the height of the character's eyes. As characters recede into the distance, the positions of the tops of their heads or their feet might change, but the level of their eyes remains consistent. Anything on the eye level, whether near or far, will remain at the same height.

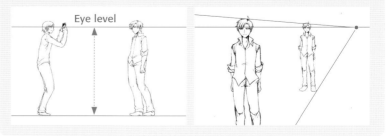

Positioning Characters with Different Heights

The Perspective Line Method and Eye Level Method are effective techniques when drawing multiple characters of similar heights. When drawing characters with height differences, determine how much difference each one has from the reference character, and discern the height of their eye levels.

When you can't draw well with just the Eye Level Method, it can be effective to first sketch the characters using the Perspective Line Method, and then adjust for height differences.

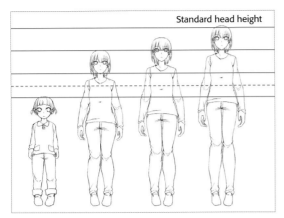

A helpful measure for height differences is to determine how many "heads" difference there is compared to the reference character.

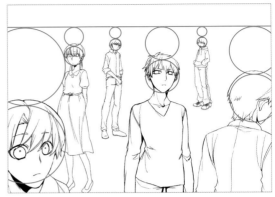

If the horizon line doesn't pass through the body, first measure the distance between the reference character and the horizon line. It's easier to understand when you gauge it by how many "heads" they are apart.

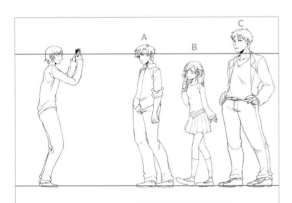

Character A has eyes positioned on the horizon line, B is shorter than the horizon line, and the large-bodied C has the horizon line falling around neck level.

Keeping in mind the principle that "objects on the horizon line will appear to be at the same distance, whether they are actually near or far," arrange characters either in front or behind based on their relationship to the horizon line, so they form a logical arrangement.

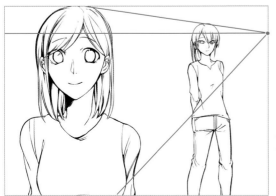

If a character's body extends significantly out of the frame, you can draw the body outside the frame to determine the eye level. However, you can also draw a guide by connecting the same parts of two bodies. While this may be less accurate compared to a full-body drawing, slight discrepancies won't be jarring in close-up shots.

Composition Examples

Do you want to highlight the protagonist? Or convey a sense of dynamism? I'll introduce a variety of composition techniques tailored to your objectives, alongside outstanding examples. Composition is not a technique that solely determines the quality of a work, but rather aids in emphasizing the author's intentions and emotions. With these composition techniques as a foundation, add your own touch and strive to create a work brimming with originality.

Creating a Sense of Stability

How can you give the illustration a neatly arranged impression? I'll introduce composition techniques that offer viewers a sense of comfort, such as motif arrangements using shapes or frame divisions using the golden ratio. Because many of these techniques are versatile and fundamental, be sure to understand them well.

Bisected Composition

- **This composition provides a sense of stability, but limits movement.**
- **It creates various contrasts with a 1:1 balance.**
- **Intentionally tilting the dividing line can also induce a sense of movement.**

Contrasting Two Worlds

Bisected Composition divides the workspace into two using horizontal or vertical lines, contrasting the two halves. The impression from a Bisected Composition is one of stability and tranquility, and it doesn't convey much dynamism.

It allows for creating symmetrical worlds or situations depicted in equal amounts, enabling clear expression of contrasts like color, brightness and darkness, clarity and ambiguity, stillness and movement, etc. If you're unsure about how to depict the background, being conscious of Bisected Composition might help.

Emphasizing the contrast between the protagonist and the antagonist can also be intriguing. It's easy to draw, and results in a stable finish, making it applicable to various scenes.

Bisected Composition essentially uses straight horizontal or vertical lines. However, to avoid a static impression, intentionally tilting the dividing line can introduce dynamism. Explore styles that fit your work.

KEYWORDS

Contrast
When you place two things with opposing characteristics side by side, their respective properties are emphasized more than when viewed separately. Examples include red and green, brightness and darkness, etc.

Radiating Lines
A technique in manga where numerous lines are drawn from the outside edges toward a specific motif in the center. This guides the viewer's gaze to the motif and can express a sense of force or emphasis.

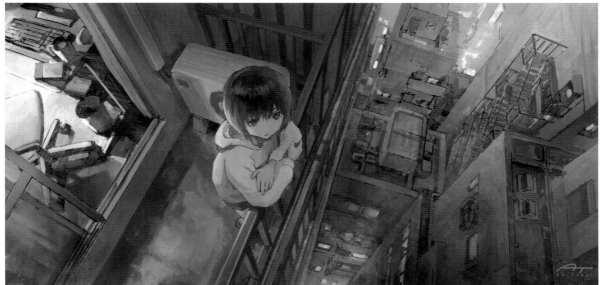

By dividing with a diagonal line, a pleasant variation is added to the typically static Bisected Composition. When there are many elements on the canvas, the space can be neatly organized by splitting the components with a single line like the one indicated above. In this piece, drawn with a deep angle perspective, the depth axis (z axis) extending downward serves as radiating lines toward the character, guiding the viewer's gaze.

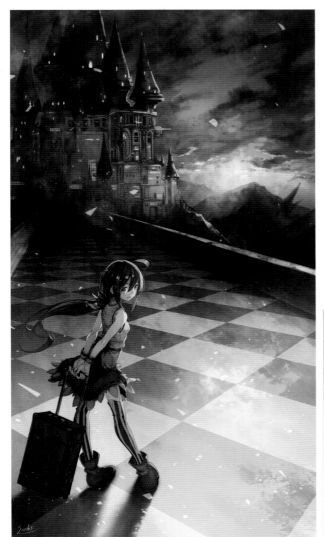

The canvas is bisected horizontally. Depicted in the upper part are timeless features consisting of the sky, sun and mountains, as well as a castle, a symbol of authority. On the other hand, the lower section portrays a traveler exuding a sense of freedom and an expansive road, skillfully contrasting the motifs above. Simultaneously, a warm, earthy tone pervading the entire image gives a unified feel.

Artists: (Top) あきま (Bottom) saraki

Rule-of-Thirds Composition

- A highly versatile composition that can be applied to various scenes.
- Depending on which of the four intersection points elements are placed, the impression changes.
- Especially recommended for those who often end up with similar compositions.

An Easy-to-Adopt Basic Composition

The workspace is divided into three parts both vertically and horizontally, and elements are placed on these lines or at their intersections. Among composition techniques, this is fundamental and can be applied to various scenes. So if you're unsure about composition, give this method a try.

The Rule-of-Thirds Composition is very convenient when there are many elements on the workspace, as it organizes and balances them well. There's a sense of stability, and a balanced canvas can be constructed. Essentially, elements can be placed on any of the four intersections, but the impression does vary depending on their positioning. Experiment during the sketching phase.

For those who get stuck in a rut with compositions like the Central Circle Composition (pages 76–77), this is particularly recommended. I encourage you to learn and utilize it.

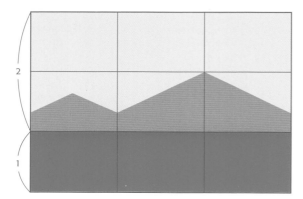

With the Rule-of-Thirds Composition, there's also a method that involves using the thirds as dividing planes. The 1:2 division engenders a sense of expansive space.

KEYWORD

Intersection
The point where lines cross. In the Rule-of-Thirds Composition, there are four intersections, each slightly offset from the frame's center. This offset produces a balanced composition.

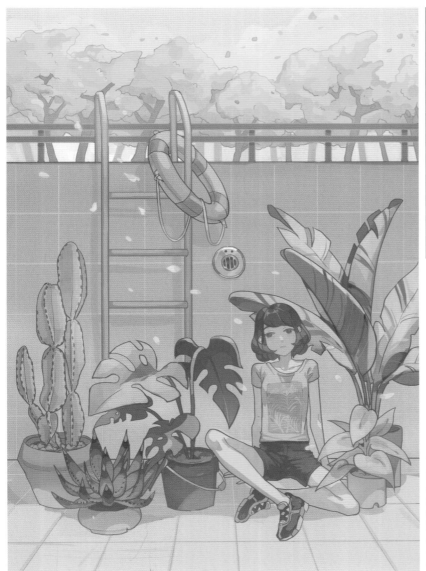

The primary object the artist wants to show (the character) is drawn at the position corresponding to the intersection of the line dividing the frame into thirds vertically and horizontally at the bottom right. The canvas appears balanced and calm, naturally directing the viewer's gaze toward the character.

Horizontal Line Composition

- This composition is perfect for when you want to express vast open spaces.
- Incorporating a horizontal line in the midground and background tightens the focus.
- Except for special situations, ensuring that the line isn't tilted provides stability.

Horizontal Lines Tighten the Focus

Horizontal lines are the most basic lines in illustration. They represent the vast freedom and tranquility of nature. Coastlines or gentle hills, for instance, can be drawn on a landscape-oriented canvas using horizontal lines without feeling out of place.

The three elements that represent the depth of a landscape are (in order from nearest to farthest): "foreground," "midground," and "background." When you intentionally use horizontal lines in the midground and background, the entire canvas becomes more coherent, providing a sense of unity.

An important detail to mind in this composition is to ensure the lines aren't tilted. A slanted line can make the viewer feel uneasy. Unless there's a real reason to tilt it, ensure that it remains perfectly horizontal.

KEYWORDS

Horizontal Line
Not to be confused specifically with a "horizon line," in this instance it is any horizontal line. When drawing a horizontal line with computer drawing software, set the tilt angle to 0 degrees.

Foreground, Midground, Background
These terms classify scenery by distance. In a frame, if you consider the protagonist to be in the midground, everything in front of it becomes the foreground, and everything behind is the background, making the spatial arrangement easier to understand.

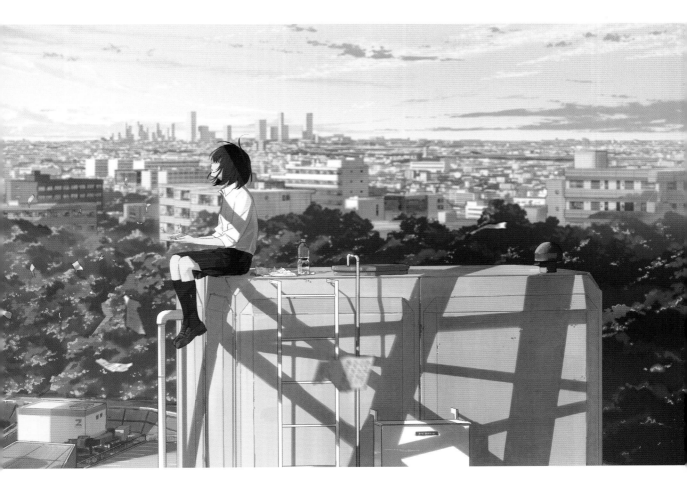

This image displays a structured arrangement of horizontal lines, providing a comforting sense of stability and tension. The character is also sitting in line with the foreground horizontal line. While buildings and trees create horizontal lines, the only diagonal lines, those of the shadows, add accents. The artwork feels as if you can sense the flow of the wind beyond the surface of the illustration.

Triangular Composition

- This composition organizes elements on the canvas and brings a sense of stability.
- It emphasizes space, allowing for expression of height and expansive depth.
- Making it a right-angle triangle creates stability and contrast.

Composition Fundamentals to Remember

Triangular Composition is one of the foundational layouts in composition, creating a triangle within the image. Triangles exude a solid sense of stability, and the wider the base, the stronger this effect. By placing multiple elements along the lines of the triangle, you can neatly organize the space. This layout is also apt for emphasizing depth and expressing expansive height and depth.

Triangles can vary in shape based on angles. Among them, when you don't want the viewer to be overly conscious of the triangle, a right-angle triangle is suitable. It differs from symmetrical triangles like equilateral triangles or isosceles triangles, providing stability with some variation and balanced movement.

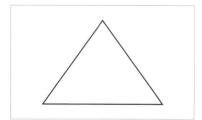

A stable equilateral triangle.

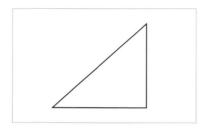

A right-angle triangle brings stability and balanced motion.

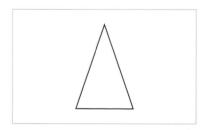

A narrow-based isosceles triangle gives a sense of instability.

A slight tilt brings variation to the image.

The wider the base, the stronger the sense of grounded stability.

The direction of the corners also influences the direction of the gaze.

KEYWORDS

Right-Angle Triangle
A triangle where one of the three vertices is 90 degrees. It combines properties of both stability and motion, making it an easily applicable shape in illustrations.

Asymmetry
Opposite to "symmetry" such as left-right or top-bottom symmetry, "asymmetry" refers to a lack of symmetry. Compared to symmetry, it feels less rigid and gives a freer impression.

Mirror Symmetry
Perfect symmetry, as if reflected by placing a mirror along an axis. It can produce a feeling as if one has wandered into a mirrored world, evoking wonder and a mystical ambiance.

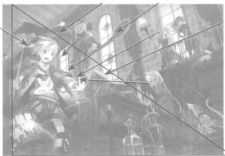

From a low angle, looking up at the right-angle triangle emphasizes the expansiveness in all directions, depth included. The gaze of the supporting characters, the window frames, handrails, pillars and other diagonal lines all focus on the main character, guiding the viewer's eyes. The distinction in the texture of various items and the sense of color bring realism and tension to the scene.

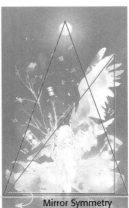

Mirror Symmetry

The base structure of the image includes an isosceles triangle connecting the full moon and the character's outfit, first establishing stability. Then, the wings and the character's body form a right-angle triangle, evoking an image similar to the hands of a clock and creating motion. Amidst the cool tone, the hourglass descending with the light from the moon and the clock's Roman numerals seem to mark a silent moment frozen in time. The beautiful mirror symmetry reflecting below the character also enhances the mysterious atmosphere.

Artists: (Top) ザザ (Bottom) ことコト

Golden Ratio / Golden Spiral Composition

- ■ This composition incorporates the ratio that humans find beautiful, known as the "golden ratio."
- ■ This technique has been widely used in architecture and paintings since ancient times.
- ■ The "golden spiral," drawn based on the golden ratio, can also be utilized in composition.

A Ratio that Produces Beautiful Balance

The golden ratio describes a proportion perceived to be beautiful by humans, equating to 1:1.618 or roughly a 5:8 ratio. It is said that by incorporating the golden ratio into illustrations, one can create "the most aesthetically pleasing composition."

The golden ratio is a proportion that can also be found in nature and has been used in architecture and paintings for centuries. Examples include the Parthenon temple in Greece, Leonardo da Vinci's *Mona Lisa*, and Katsushika Hokusai's *The Great Wave*. Even today, it has been used in the logo designs of companies like Apple, as well as Twitter ("X") and others.

Here, we will explore compositions that utilize the "golden spiral," a derivative of the Golden Ratio Composition.

■ How to Draw the Golden Spiral

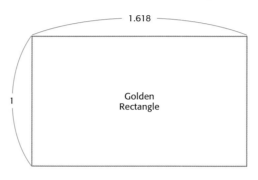

❶ Draw a rectangle with a ratio of 1:1.618. This is called the golden rectangle.

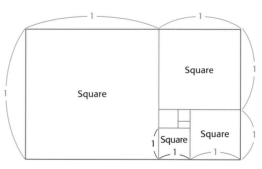

❷ Draw a square using the shorter side of the golden rectangle as the base. Continue to draw squares in the remaining space in the same manner, repeating this process.

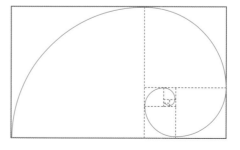

❸ By carefully connecting the corners of each square with an unbroken curve, you'll create a soft spiral shape reminiscent of a seashell.

KEYWORD

Golden Ratio
One of the "precious metal ratios." Apart from the golden ratio, there are other ratios like the silver ratio, bronze ratio and platinum ratio.

The character's proportions and the expanse of the outfit form a beautiful scene that exhibits the Golden Spiral Composition. When incorporating the golden spiral into an illustration, it's not necessary to align perfectly with the line. Even if only a part of the illustration matches the spiral, it works. As a result, as seen in this illustration, one can incorporate it naturally without making the viewer overly conscious of its use.

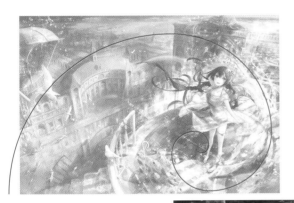

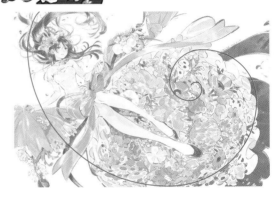

The path connecting the rainbow's light and the birds and tropical fish forms a flowing golden spiral. The golden spiral naturally guides the viewer's eyes to the character within. Artistic skill, creativity and aesthetic sense combine in a balanced composition, delighting the viewer.

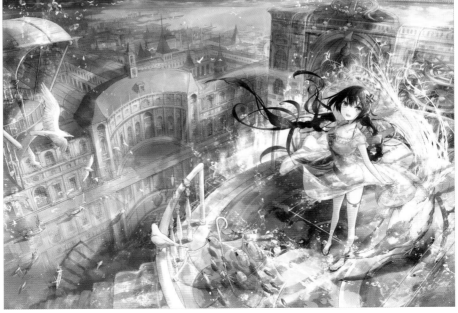

Artists: (Top) 海島千本　(Bottom) ふーみ

Silver Ratio Composition

- ■ The silver ratio is a numerical relationship that has been employed in artistic works for a long time.
- ■ One can create contrast within the frame using division lines.
- ■ It serves as a hint when deciding the placement of multiple characters or elements.

A Ratio Familiar to the Japanese

The silver ratio corresponds to a 1:√2 ratio (approximated as 1:1.414). Also known as the "Yamato Ratio," it is a proportion found in Japanese architecture, sculptures, Buddhist statues, ikebana (Japanese flower arranging), ukiyo-e (traditional Japanese woodblock prints) and more. It could be said that this ratio is more familiar to the Japanese than the golden ratio (page 21). The silver ratio is also utilized in paper sizes such as A4 and B4, and the proportions remain unchanged even if the longer edge is divided in half.

There are primarily two methods for applying the silver ratio to illustrations. One method is to draw a dividing line at a 1:1.414 ratio and place the main elements along that line. Another method involves contrasting two divided spaces by giving them distinctive appearances. It's a good idea to incorporate this balanced Japanese ratio into your artwork.

■ Positioning Important Elements on the Division Lines

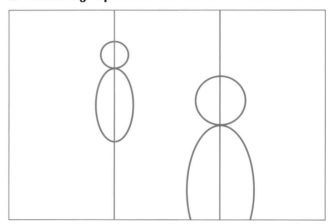

■ Drawing Contrasting Features in Spaces A and B

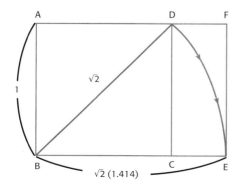

How to Draw a Silver Rectangle
(A rectangle where the sides have a 1:√2 ratio):

1. Draw a square (ABCD).
2. With B as the center, draw an arc with radius BD and let its intersection with the extension of line BC be point E.
3. Using a compass, measure BE, and mark a point F on the extension of AD such that AF=BE. Connecting EF gives the rectangle ABEF. The vertical to horizontal ratio of rectangle ABEF matches the 1:√2 silver ratio.

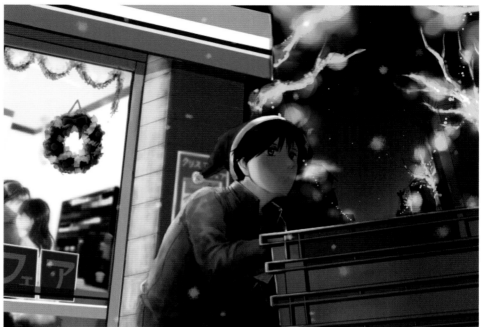

Dividing the frame by the silver ratio, the boundary between the inside and outside of a convenience store is set along that line. This division is used to contrast various elements like temperature and light and dark, narrating a story. Viewers can quickly comprehend the setting and empathize with the characters portrayed in the image.

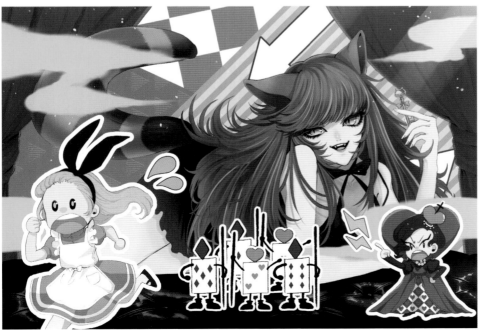

The main character, with cat ears, is drawn with her face overlapping the division line. The two divided spaces each contain opposing mini-characters, providing structure to the illustration. By organizing and placing multiple characters with intention, viewers can easily immerse themselves into the world of the artwork.

Golden Section / Golden Ratio Division Composition

- **This composition represents a division based on the beautiful proportion known as the "golden ratio."**
- **It results in a cohesive and stable framework.**
- **The Golden Ratio Division Composition is a method that combines both movement and proportion.**

Applying the Golden Ratio to Divisions

In composition methods using the golden ratio, aside from the Golden Spiral Composition, there is a Golden Section Composition which simply uses the ratio of the golden ratio (1:1.618). This method places essential elements on or at the intersections of the golden ratio dividing lines. One can also use the rectangular spaces formed between these lines. When the frame has many elements, use these intersections, lines and areas to achieve a harmonious composition.

Moreover, there's a Golden Ratio Division Composition using the "phi grid." The phi (golden-ratio) grid involves drawing a rectangle at a 1:1.618 ratio, and then drawing diagonals between the four corners, followed by horizontal and vertical lines at the intersections, and then diagonals at the intersections that are at right angles to the first set of diagonal lines. The four intersections (ABCD) formed are called the "golden section points." By placing elements along these golden section points or the diagonal lines, the composition becomes dynamic and balanced. Hence, Golden-Ratio-Division Composition is also referred to as "dynamic symmetry."

■ **Golden Section**

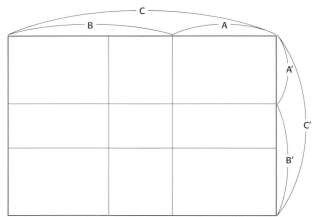

A(A'):B(B')=1:1.618 B(B'):C(C')=1:1.618

■ **Golden Ratio Division (Dynamic Symmetry)**

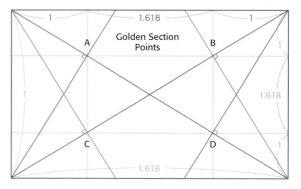

KEYWORD

Grid
Refers to a structured arrangement where straight lines run vertically and horizontally in a regular pattern. In the fields of illustration and design, it's used as a guide when positioning elements.

This composition uses dynamic symmetry. By using the golden section points and diagonal lines as guides to place elements like characters and background details, the result is a composition with both movement and a sense of stability. The balance of light and shadow, detailed rendering and negative space, as well as distinctive textures for each motif make for an exquisite illustration.

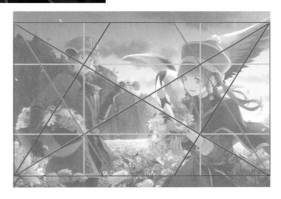

This is a composition based on the golden section, using the proportion of the golden ratio—1:1.618. The "areas" of the golden section are used to divide the space into two, distinguishing each character with differences in brightness and hue. Additionally, by positioning the main character's face on the dividing line, the composition achieves a stable and well-balanced appearance.

Symmetrical Composition

- This composition yields a landscape seldom seen in the real world, giving a unique and mysterious impression.
- It emphasizes impressions of serenity, elegance and orderliness.
- Intentionally breaking the balance can bring variation.

The Beauty of Symmetry

From ancient times, symmetry has been incorporated into sculptures, paintings, architecture and more. Applying this concept to illustration composition, we have Symmetrical Composition, where the frame is divided in two and elements are arranged in mirror image. While it could be considered a type of Bisected Composition due to the division, having similar motifs on both sides of the dividing line introduces intrigue, mystery and stability. Instead of perfect symmetry, you can introduce unique elements to one side or intentionally disrupt the balance to incorporate motion and transformation.

There are primarily two types of symmetrical compositions. One is arranging elements of similar shape and size, and the other is creating symmetrical images through reflections in mirrors, glass, or water surfaces. The beauty of symmetry lies in its ability to put forth impressions of tranquility, elegance and orderliness. Combining these attributes with backgrounds and objects that emphasize them enhances the composition further.

In nature, few things possess perfect symmetry. Symmetrical composition is a form that represents human fascination with this rarity.

KEYWORD

Symmetry
This term refers to the arrangement where elements of the same shape are placed on either side of a central axis or point, either horizontally or vertically. Not just line symmetry, but there's also point symmetry and rotational symmetry.

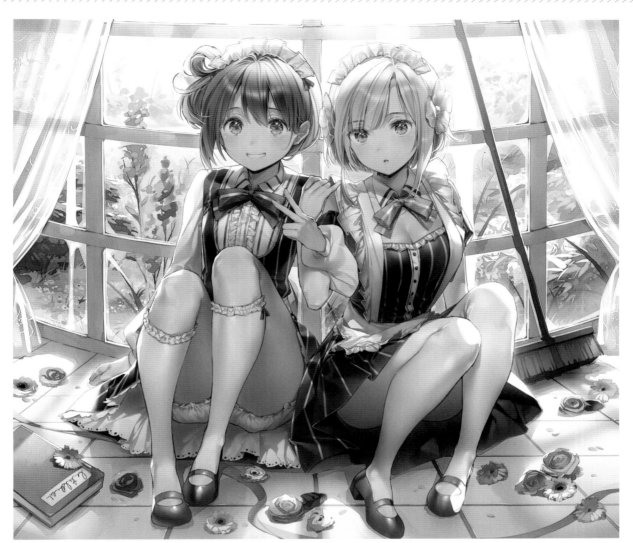

Using the vertical window frame in the center, characters and items are symmetrically placed. There are subtle differences in the expressions, costumes and poses of the two characters, introducing variation. Most eye-catching is the charm of the characters. The lines of the window frame and floor act as leading lines directing the viewer's gaze toward the characters, enhancing their appeal even further.

A large puddle formed on the trolley tracks after the rain.
Reflected in it is a beautiful mirror-symmetrical image.
Additionally, the landscape above and below transcends
time and place, depicting a mysterious and captivating
space. The depth axis of the buildings and the sky formed
into triangles are alternately arranged, creating a sense of
stability and a rhythm of movement.

Making the Protagonist Stand Out

There are many ways to make the protagonist stand out on the canvas. For example, one can drastically unbalance the ratio between the character and the background, or use lighting effects to guide the viewer's gaze. The key is to add strong contrasts.

Central Circle Composition

- ■ **This is the most effective composition method to convey the charm of the main character.**
- ■ **It places strong focus on the main motif.**
- ■ **Enhancing with techniques like shading and focus can further increase its impact.**

Directly Expressing What You Want to Show

The Central Circle Composition places the main character or other primary element in the center of the canvas, while keeping the surrounding details subdued. In Japan it's called *Hinomaru*, due to its resemblance to the Japanese Rising Sun flag. The face of the character in the center tends to be drawn facing forward or with the character making eye contact with the camera. This makes a strong impression, as if the character and the viewer lock eyes at first glance. Moreover, since the viewer's gaze isn't led away from the center of focus, this composition tends to convey more stability compared to a triangular composition. Although its simplicity might be perceived as "amateurish" or "cutting corners," it's the most effective composition when you want to convey the main character's charm directly. The Central Circle Composition's strength in concentrating the viewer's gaze stands out among composition methods and is often used in card game illustrations. With proper attention given to shading and focus, you can create a more captivating illustration with a stronger centrally focused emphasis.

In terms of concentrating the gaze, the Central Circle Composition is the most effective. When used properly, it can convey the character's charm more powerfully than any other composition method.

KEYWORDS

Camera Gaze
Drawing the character's gaze as if making eye contact with the viewer. In photography, it's like when the subject looks directly into the lens. Use it when you want to make the character particularly noticeable.

Card Game Illustration
Illustrations for trading cards or for digital games that incorporate card elements. Since they introduce characters, the Central Circle Composition is often used.

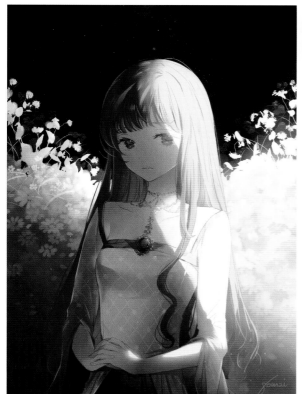

Not only placing the main character in the center of the canvas, but also subtracting elements to set the character against a simple background makes the character stand out. The Central Circle Composition, which strongly concentrates the gaze, requires the character to be captivating. In this piece, you're drawn to the character's melancholy expression.

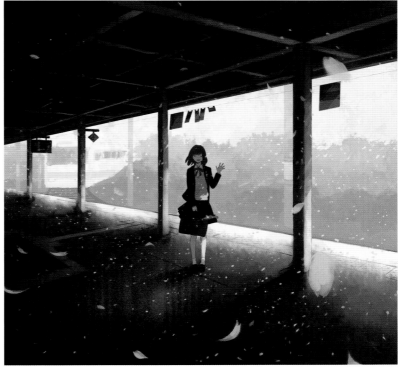

By contrasting the light and shadow of the character and the background, the protagonist is clearly highlighted. Also, by placing the character on the line of a one-point perspective platform of a train station, the attention drawn to the character is further intensified.

Framing Tunnel Composition

- This composition emphasizes the protagonist by enclosing them in a frame-like structure.
- It produces a captivating effect, pulling the gaze deeper into the image.
- The motif or shape serving as the frame can be freely arranged.

Glimpsing into the Illustration

Framing Tunnel Composition is a technique where the main subject is emphasized by enclosing them in a frame-like element. Additionally, by applying a contrast in lighting, you can create a three-dimensional depth. People have a natural tendency to focus on enclosed objects, so elements you want to showcase can be emphasized using a frame. It gives the feeling of peeking through a tunnel or window, directing the viewer's gaze deeper into the space. By framing the image, it also tends to give it a tranquil impression.

There's also a reverse tunnel composition where the main character is in the foreground and a tunnel is placed in the background. While frames are often made using man-made structures like window frames, entrances or archways, natural objects like trees can also be used. The shape of the frame doesn't have to be rectangular or semi-circular. It can be freely customized.

If the frame area is large, it intensifies the effect of the gaze being pulled deeper into the background. If the frame is small, it resembles a decorative picture frame, weakening the pulling effect.

KEYWORDS

Contrast
Refers to differences in color, brightness and shape. By creating areas of strong contrast within an image, elements complement each other, giving the picture more dynamism.

Natural Objects
Things that exist in nature untouched by human hands. In the Framing Tunnel Composition, trees can serve as frames, or it can depict a view from within a cave looking outward.

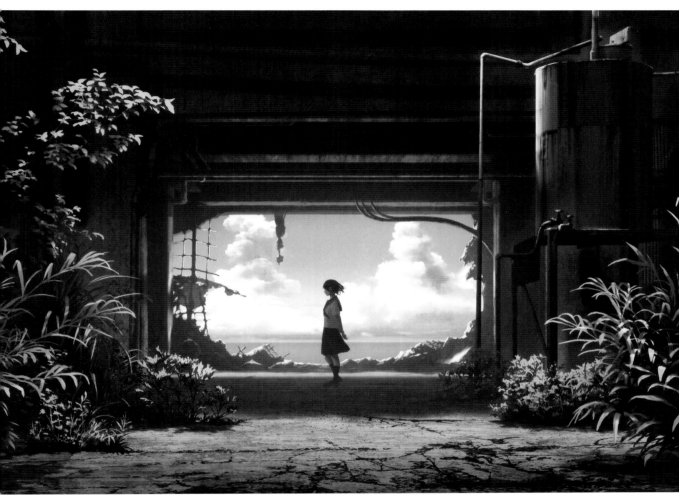

The character is surrounded by a dark tunnel-like structure. The faint sunlight illuminates the grass in the foreground, the midground has the tunnel and the character depicted in silhouette, and beyond the tunnel stretches a dazzling sky and sea in the background. These three positions are skillfully depicted, making the viewer sense a vast space expanding into the distance, seeming connected by the flow of air.

Sandwich Composition

- ■ **This composition can be used to emphasize important elements such as primary characters.**
- ■ **It creates a sense of immersion.**
- ■ **Effective use of negative space gives a sense of openness.**

Emphasizing by Enclosing the Subject

There are various compositional techniques that involve framing a motif, and Sandwich Composition is one of them. With this method, main motifs such as characters are encased between lines of architectural or natural elements, emphasizing the focal point and concentrating the viewer's gaze to enhance the sense of presence. Unlike the Framing Tunnel Composition that encloses from all four sides, this method produces negative spaces, bringing a sense of openness to the frame.

The image can significantly change depending on the canvas orientation (horizontal or vertical) and the direction of the enclosing lines (top-bottom or left-right). Experiment with various combinations.

KEYWORDS

Sense of Immersion
When viewing an illustration, it is the feeling of being present in that scene. Not just through realistic depictions, but also through captivating gaze-guidance and lively character portrayals.

Negative Space
The space set around motifs or characters. It doesn't require leaving these areas entirely blank, but it refers to a space where one can see far into the distance without obstructions.

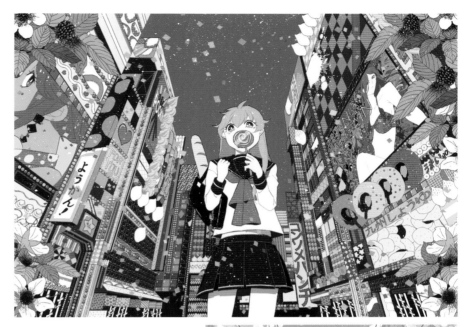

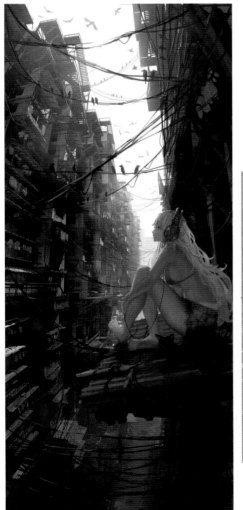

Buildings with vibrant colors accentuate the main character by their framing presence. The perspective lines of the buildings extend radially, and by placing the character at the center, the viewer's gaze circumnavigates the intricate details of the background, ultimately returning to the main character. The artwork doesn't feel cluttered despite all of its details, thanks to the effective use of the open sky.

The distortion, similar to what's achieved with a fisheye lens in photography, intensifies the sense of immersion. The narrow space between the buildings emphasizes the bustling human activity, while the endless sky and fluttering birds evoke a sense of freedom, providing a great contrast. Zigzagging power lines guide the viewer's gaze toward the character. The chaotic cityscape juxtaposed with the ethereal presence of the character accentuates its allure.

Circular Formation Composition

- There is a method to arrange items for equal emphasis, and another to emphasize one element over others.
- In a circular composition, the gaze moves around in a roughly Z-shaped line.
- This technique is widely used in the field of design.

Considering the Path of Gaze in Placement

In this composition, characters are placed following a circular pattern, and there are generally two types of arrangements. One method is to arrange motifs of similar size at even intervals to create a parallel relationship. The other method involves drastically changing the shape, size or placement of the main character to guide the gaze and make it stand out.

In the former case, where characters are arranged in a circular formation, the path of the gaze moves in a circle around the entire composition, or it follows a Z-shaped path, starting from the top left, moving to the top right, then down to the bottom left, and settling at the bottom right. For this arrangement, it's recommended to place an eye-catching element ("eyecatcher") at the starting point (top left) and place an essential element at the endpoint (bottom right). This rule of arrangement is called the "Gutenberg Diagram," and it is used in magazine layouts and the like.

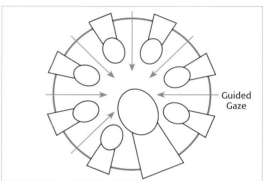

Guided Gaze

The gaze starts from the top left and moves in a Z shape, ending at the bottom right.

KEYWORDS

Eyecatcher
A Japanese-English term that refers to something in a scene that catches the eye first. In anime on broadcast television, this term is sometimes used to refer to the title credits that come after a commercial break.

Gutenberg Diagram
A principle that describes the effect that occurs during observation of something with evenly distributed information, where the gaze moves from the top left to the bottom right. The recognition of this effect is attributed to Edmund Arnold, who named it after Johannes Gutenberg, the inventor of moveable type.

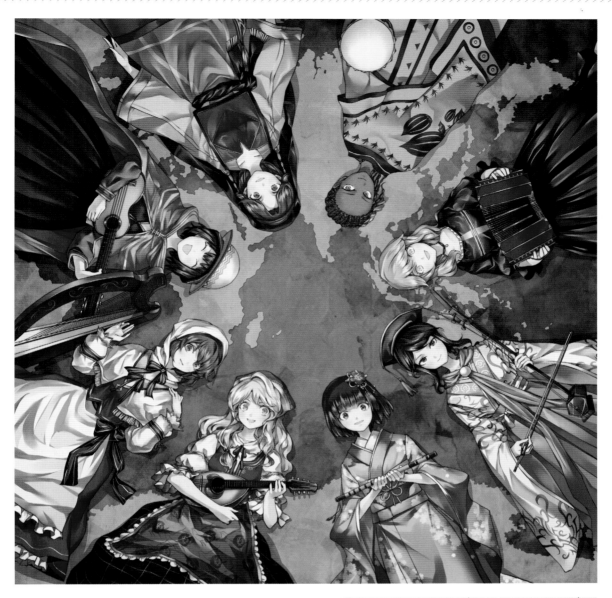

Characters dressed in traditional outfits from various countries are evenly placed in a circle. The flared skirts form A-shaped lines, also making it a triangular composite composition, striking a balanced feel between stability and dynamism. The viewer's gaze moves along the circle in a roughly Z-shaped path. Regarding this path, the gaze first goes to the character in the pink costume, moving across the scene to end on the character in the traditional Japanese dress. The way that the space around the face of the character in the traditional Japanese dress doesn't overlap any of the map's depicted landmasses might appear at first to be random chance, but in fact it has been carefully designed into the composition.

A-shaped line

Blur and Focus Composition

- With this composition, the gaze is focused on what's not blurred.
- The depth is emphasized to give a three-dimensional look to the image.
- Using an effect like a mist or haze can create a fantasy atmosphere.

Enhancing the Look of the Depicted Environment with Finishing Effects

One of the techniques used to highlight characters is blurring. By applying blur to nonessential areas, one can diminish the presence of less important elements or guide the gaze toward unblurred subjects. For example, you can apply blur to objects in front of and behind the main character, focusing on the main character to emphasize it further. This method can also accentuate depth or create a fantasy ambiance.

When drawing with computer graphic software, it's recommended to keep the character or element of emphasis on a separate layer so the background can be blurred in an isolated way. Choose the "Gaussian Blur" filter (in Photoshop; the name varies in other software) and adjust the range of the blur while checking the overall balance on the screen.

KEYWORDS

Focus
This refers to the camera's focal point, also known as "sharpness." When incorporated in illustrations, areas in focus are depicted clearly, while out-of-focus areas are blurred.

Filter
A function in graphic software that provides various effects like blurring, lighting effects, noise, etc. Often used for final adjustments or "post-processing" to tweak the entire screen's look.

Gaussian
One type of blur filter. It provides a soft, natural blur similar to a photographic representation, making it a widely recognized and frequently used filter.

Blurring objects in front of the main character is called "foreground blur." This type of blurring can produce the effect of a Framing Tunnel Composition, guiding the gaze from the foreground to the background, expressing depth. It also has the effect of creating a fantasy look to the image. In this work, the blurred leaves and rain give the impression of gently enveloping the character.

By blurring the characters in the foreground and the distant background and focusing on the main character, the gaze is directed to one concentrated point. The purity in the young girl's expression, her hairstyle, outfit, accoutrements, right down to her fingertips, reveal the meticulous attention to detail paid by the artist.

Spotlight Composition

- A composition that depicts the play of light in a way that highlights the protagonist.
- This technique enhances the presence of the protagonist by boosting their level of brightness.
- This method results in an image with high contrast, creating a dramatic effect.

A Single Ray of Light Illuminating the Protagonist

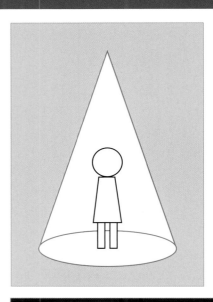

Light, shadow and darkness created by illumination are essential elements that add depth and dimension, influencing the portrayal of the illuminated subject. One type of lighting equipment you are probably familiar with is the spotlight. It's primarily used to direct the audience's attention to a part of the stage during plays and concerts, illuminating a specific point of interest.

The light (and surrounding shadow) of a spotlight instantly distinguishes the main character from secondary characters, magnifying the main character's presence. Using the spotlight effect imparts a dramatic impression in your composition.

As light from multiple sources overlaps, it gets brighter and approaches white. This is called "additive color mixing" or "additive color synthesis." In contrast, with paints, layering colors make them gradually darker, nearing black. This is termed "subtractive color mixing" or "subtractive color synthesis."

KEYWORDS

Sense of Depth
The depth and three-dimensional expanse felt from a depicted space or motif. Skillfully control light and the intensifying of contrast between light and dark to emphasize this impression.

Vermeer
Johannes Vermeer was a Dutch artist who flourished in the seventeenth century during the Baroque Period. He is known for his remarkable use of light, with famous masterpieces like *Girl with a Pearl Earring*.

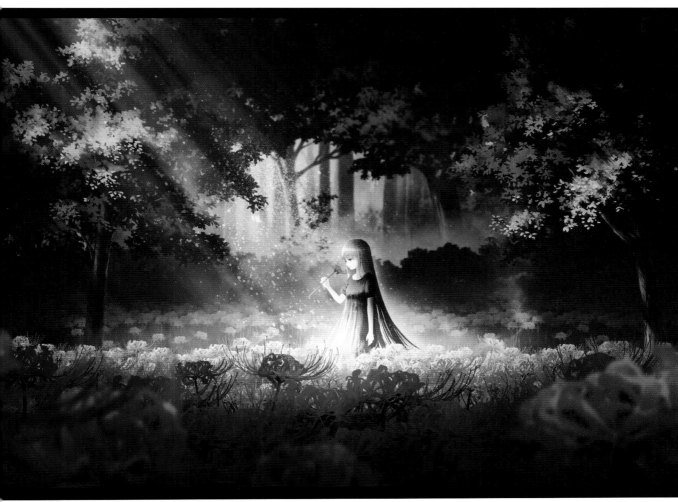

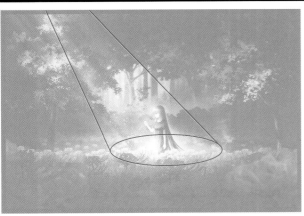

Illumination uses light, shadow and darkness to direct the gaze and emphasize the impression of the illuminated character. In this artwork, the light filtering through the trees and clouds beautifully accentuates the character's silhouette. In particular, oblique lighting (light coming from an angle) serves as a device to highlight the protagonist, reminiscent of Vermeer's paintings.

Quadrant Composition

- This composition can express the presence of the character and the sense of scale of the background.
- This technique is more effective when presented on a simple illustration with restrained elements.
- This unusual composition brings with it the potential to broaden your range of expression.

Bold Composition Highlights the Protagonist

To emphasize the protagonist, methods like placing the protagonist clearly in the center, such as the Central Circle Composition, are good to use. However, there's also a composition where you intentionally draw the main character (or whatever you want to highlight) small and restricted to one quadrant of the panel. The contrast of the area between the character and the background can be used to express the character's presence, feelings of isolation, or the grand scale of backgrounds like the sky, sea, mountains or cityscapes.

Quadrant Composition is most effective when the image is kept simple, with limited information. If too cluttered, the protagonist can get lost in the background. A composition where a character is placed alone in a small portion of an expansive background can create a striking, uncommon scene, which is recommended. Even if your first thought was to feature the character on a large scale, boldly using the Quadrant Composition just might result in an intriguing, memorable image.

KEYWORDS

Presence
A term that refers to something having a strong assertion of its existence, drawing attention to itself. To amplify a character's presence, not only does the portrayal of the character need to be captivating, but guiding the viewer's gaze is also crucial.

Scale
This term refers to the size of things—not just for tangible objects, but also to express perceived magnitude, as in "a story of grand scale."

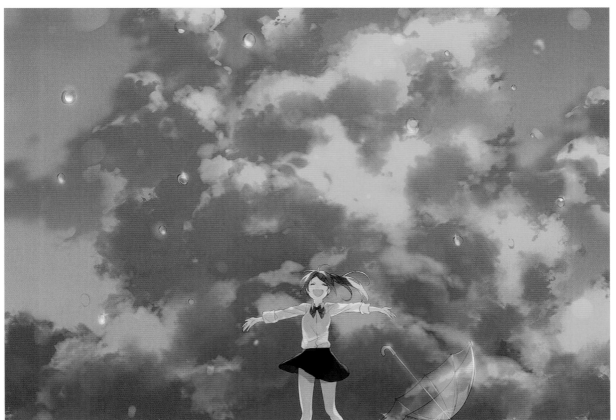

The image is filled with grandeur, freedom and a sense of openness. The movement of clouds spreading outward and the broad smile and dynamism of the character evoke feelings of youthfulness, the future and hope. The subtractive expression of placing the small character at the edge of the panel paradoxically accentuates the charm of the character.

The main character is placed at the right edge, expressing the size of the aquarium and the leisurely passage of time. It almost feels as if the character is inside the tank, enveloped by the water, conveying a sense of comfort and tranquility. Furthermore, the character's gaze and expression lead one to imagine an unspoken narrative.

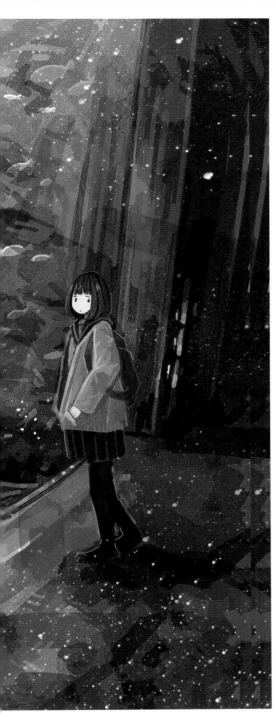

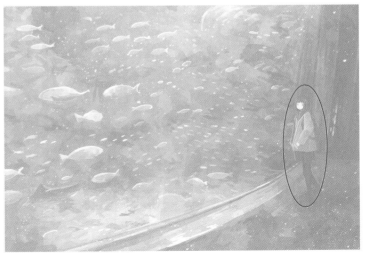

Out-of-Frame Composition

- **Even a main character without a strong personality can be highlighted using Out-of-Frame Composition.**
- **The use of addition and subtraction creates contrast.**
- **This technique is particularly effective in scenes where multiple characters appear.**

Controlling Presence

In a page or panel, the main character featured there isn't always going to be a character that's dazzling, commanding or otherwise noteworthy. Perhaps the character is reserved and unassuming. When you depict a subdued main character with a sub-character who has a strong personality equally, the sub-character often stands out more, resulting in a panel that feels unnatural and chaotic. In such cases, the Out-of-Frame Composition is useful. "Out-of-Frame" refers to intentionally cutting off something in the frame. Non-protagonists are portrayed with a subdued presence, almost as if they are minor characters on the edge of the frame, highlighting the main character. To reduce the presence of strong sub-characters, parts of their bodies might be left out or blurred. By subtracting from assertive sub-characters and, in contrast, fully incorporating the main character with an additive approach, you'll bring forward the character with desired focus.

KEYWORDS

Subtraction
Subtraction is the concept of omitting or pulling back elements that would weaken the impression of the protagonist. Use it effectively in combination with addition to balance the scene.

Addition
Addition is the concept of adding elements or details to emphasize the protagonist. It's applied to adjust the balance of contrast in a scene.

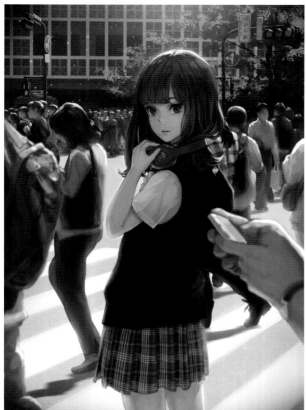

Characters other than the protagonist are subdued by blurring them, and not showing their full bodies or faces. On the other hand, the main character firmly attracts the viewer's eyes to the face, using a bold red color for the headphones. This is a great example of effectively using subtraction and addition. The sign text displayed on the traffic signal isn't blurred, ensuring readability, subtly clarifying the setting of the scene.

There are five unique characters in this illustration. When lined up side by side, it's difficult to determine who the main character is. However, placing only one front and center clarifies the situation. Moreover, the color tones based on black and brown and the texture of the shading produces a retro image, lending a stylish look to the artwork.

Five Roles, Four Scenes Composition

- **This composition incorporate techniques from movies posters and novel covers to organize components.**
- **It clearly defines who the main character is.**
- **It prompts the audience to imagine the story by indicating each character's role.**

Highlighting the Protagonist on Stage

Borrowing the Five Roles, Four Scenes Composition from movie poster and novel cover design for use in your illustrations will help to organize elements, making your intended focal point clear.

Having a recognizable main character at first glance gives the viewer a sense of reassurance. Conversely, if the main character is ambiguous, it creates an unstable impression and the viewer may feel uneasy. Balancing the Five Roles, Four Scenes Composition so that each role is clear can evoke the story and settings imbued in the work, stimulating the viewer's imagination.

Five Roles:

1. Main character
2. Character who complements the main character
3. Sub-character(s)
4. Accent item (props)
5. Setting

Four Scenes:

1. Foreground
2. Midground
3. Background
4. Scenery

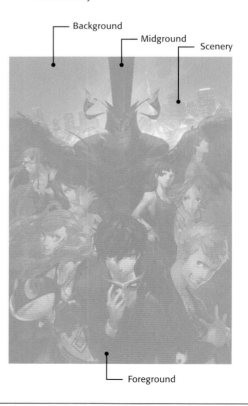

Setting — The character who complements the main character — Sub-character(s) — Accent item — Main character

Background — Midground — Scenery — Foreground

KEYWORDS

Accent item

Something in the image that catches the eye or serves as a point of focus, preventing the illustration from being monotonous. Sometimes, standout colors are referred to as "accent colors."

Prop

Items added to highlight the protagonist or tighten the focus. Things that the main character holds, for instance, fall into this category.

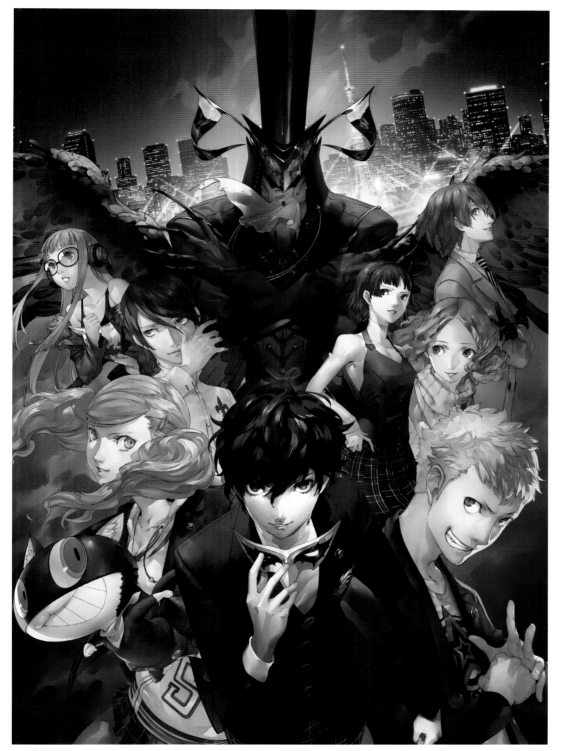

By placing the main character in the center of the foreground, sub-characters and complementary characters are set in the midground while emphasizing their unique character designs. Additionally, distinctive costumes and masks serve as accentuating items, and the setting is defined by a nighttime city skyline in the background. The roles of the characters are immediately apparent, providing a sense of clarity to the viewer. Furthermore, positioning the main character at the lower apex of an inverted triangle creates a sense of dynamism and expresses a feeling of suspense.

Pyramid Composition

- This composition incorporates a triangular configuration reminiscent of a pyramid for stability.
- It places the main element near the apex of the triangle.
- Given its tendency toward giving a static impression, be selective about where and how you use it.

Instill Stability, and Place Focus on the Protagonist

This composition literally uses the shape of a pyramid. Among triangular compositions, it emphasizes a strong sense of stability.

 The pyramid shape has its center of gravity at the bottom, with an apex at the top, resembling an equilateral triangle. This shape leads the viewer's gaze to the apex, akin to the tip of an arrow. Accordingly, you should place the most important elements of the image, such as the main character's face, near the apex.

 This composition makes for a bold presentation. Variations include placing the main character in a triangular pose in the center or positioning elements around a mountain in the background. Its dynamism is weak, so reserve it for when you want to emphasize stability.

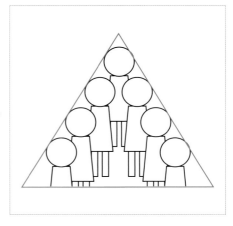

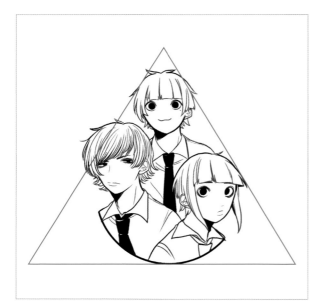

KEYWORDS

Equilateral Triangle
A triangle with all three sides of equal length. Naturally, all three of its corner angles are also equal, each being 60 degrees. An upright equilateral triangle gives a sense of stability.

Posing
The act of a character taking a pose, or the pose itself. As with composition, shapes like triangles or circles can also be incorporated into posing.

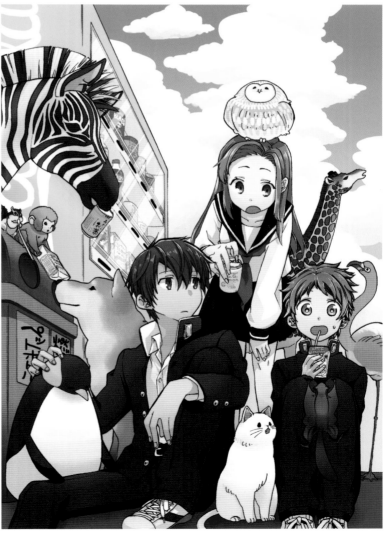

In this illustration featuring whimsical and lively characters, the face of the female character is placed at the apex of the pyramid, drawing attention there. By maintaining a white space around the apex, the image becomes easier to comprehend and it clarifies who the main character is. The contrast between the colorful tones and the white space creates a pleasing juxtaposition.

Conveying a Sense of Dynamism

A scene that looks like it's in motion captures the viewer's heart at first glance. Intentionally add a bit of pleasing movement to your panels as often as you can. Emphasizing levels of depth and establishing a path where the gaze naturally travels are both crucial factors for expressing movement in the implied three-dimensionality of the depicted space.

Curved Line / S-Shaped Composition

- **Incorporating curves into female posing creates a soft and sexy impression.**
- **Using it in the background can emphasize perspective and rhythm.**
- **For expressing expansive depth of space, a vertical orientation is more effective.**

Making Use of Curves

The form of a curve creates a soft impression in a scene, particularly for female characters' poses. The S-shaped line can evoke a soft, feminine impression and a sense of sexiness. Moreover, incorporating an S shape into the background depiction can express a sense of depth and rhythm, as if the space is winding and expanding slowly. The Curved Line / S-Shaped Composition is more effective for emphasizing depth when depicted vertically. When arranging four or more similar motifs, placing them along the curve of an S-shaped line can naturally and effectively create a sense of balance and depth.

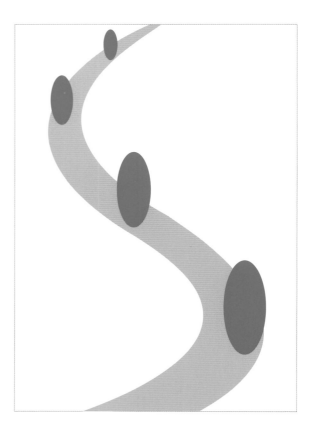

KEYWORD

S-Shaped Line Pose
A pose where the body line twists into an S shape. In standing figures, emphasizing the curves of the line between the face, shoulders, hips and knees can evoke sexiness and dynamism.

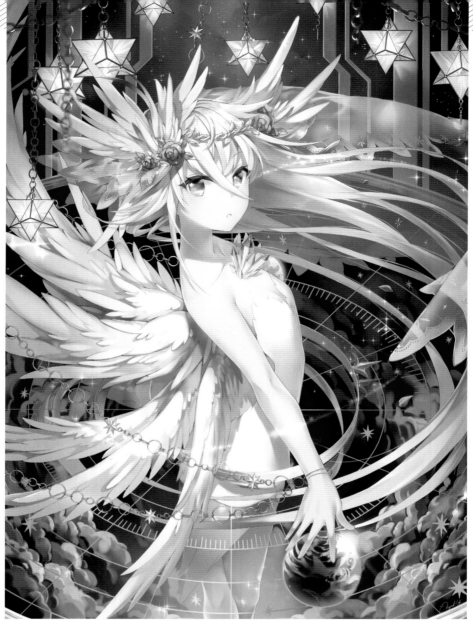

The beautiful flowing lines of the hair, the curve of the wings, and even the supple pose of the character all utilize soft and relaxed curves. To express femininity, it's crucial to take advantage of curves, as in this work. Furthermore, the sharp straight lines at the top of the image contrast with and highlight the curves.

Diagonal Line Composition

- This composition emphasizes the diagonals in the scene for a dynamic image.
- Using diagonals can easily bring out the intensity of longer motifs.
- Arrangement control is challenging, so be careful.

Creating Movement with Diagonal Lines

This is a composition method that emphasizes diagonal lines within a frame. The more diagonal lines there are, the more dynamic and lively the scene becomes, creating rhythm. It's suitable for depicting the implication of speed, as with a running character, for instance. By intentionally drawing backgrounds, trees, streetlights, etc. with diagonal lines, you can produce a sense of space and depth. Diagonals, being the longest lines in the frame, are ideal for emphasizing the presence of long motifs. Compared to the relative stagnation of horizontal and vertical lines, diagonals connote motion. While the impression that diagonal lines create is pleasingly lively, their arrangement can be tricky, so take your time planning their placement. Adjust as needed while observing the overall balance.

KEYWORD

Diagonal Lines

In a rectangle, the longest possible diagonal line is one that connects opposing corners. This long line bisects the panel, offering a compositional technique that can easily combine strong visual impact with a harmonious impression.

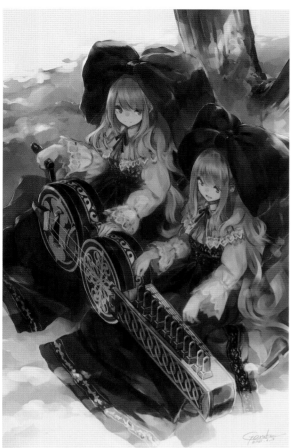

Considering the two characters and the instrument as one motif, they are skillfully arranged along a diagonal path. When drawing such long motifs, placing them diagonally ensures a good fit and emphasizes the motif's presence. Furthermore, surrounding the shadowy areas with brighter areas is a distinctive feature, drawing attention to the characters. It gives viewers the impression of peering into depth.

Using a diagonal line as a reference, the area of the sky and the space the characters occupy are skillfully divided into sections. Diagonals extending in multiple directions create flow and movement in the scene, resulting in a dynamic portrayal. The bold application of colors pairs well with the comical situation. The balance between the densely packed elements and the open space around them, as well as the contrast, are also key features.

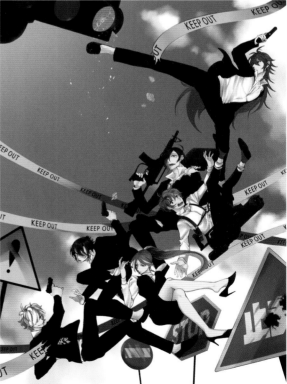

Artists: (Top) Garuku (Bottom) N³

Perspective / Radial Line Composition

- This type of composition can emphasize the expanse of space dynamically.
- It uses the depth axis perspective lines to enhance three-dimensionality.
- Placing the main character near the vanishing point increases their presence.

Emphasizing Width, Height and Depth

Perspective / Radial Line Composition refers to a layout where perspective lines radiate from a vanishing point. It dynamically represents the horizontal expanse and depth of the image, creating a striking effect that directs the viewer's gaze. While it can be considered a type of diagonal composition due to the diagonal lines, having a vanishing point within the frame more clearly directs the viewer's gaze compared to diagonal compositions. This composition can be useful when depicting roads extending from the foreground to the background. By placing the main character near the vanishing point where the gaze is led, attention drawn to the character is exceptionally heightened. Moreover, when also working with a wide-angle view, the perspective lines are emphasized, allowing for the expression of space's expanse.

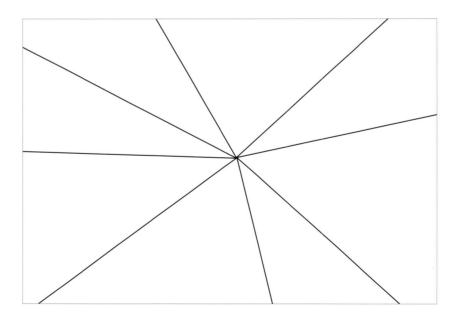

KEYWORDS

Vanishing Point
The point where two or more perspective lines converge. It exists at eye level. Imagine a straight railroad track disappearing into the distance to easily understand this term.

Perspective Lines
Guide lines drawn when preparing a linear perspective drawing. The lines lead to the vanishing point.

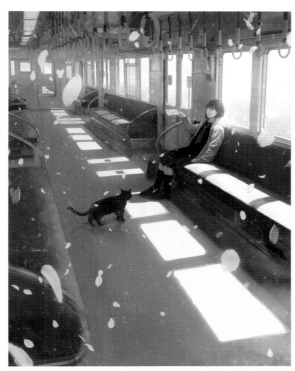

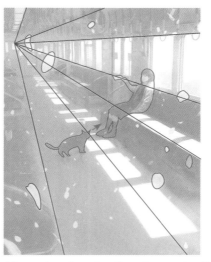

A key point when drawing a Perspective / Radial Line Composition is to discern the lines emanating from the vanishing point. In this piece, the ceiling lights, hanging straps, windows, seats and the light streaming from the windows align to these lines. In addition to the flow of lines, the cat's gaze, which is directed at the protagonist, also heightens the focus on the main character. The vanishing point being outside the vehicle induces viewers to imagine the scene beyond, and the falling petals add to the poetic image, making it a dramatic piece.

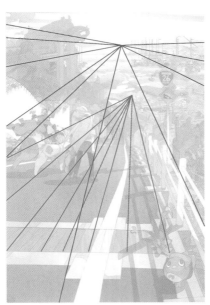

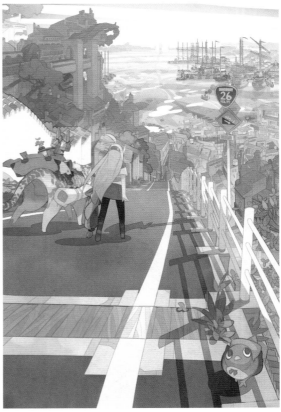

The downhill lines of a slope emphasize both depth and dynamism. Separate from the horizon's vanishing point, the subtly winding slope with its descending levels has multiple vanishing points. The base of the triangle formed by the road is broad, lending a sense of stability. The background leading from the sea to the sky employs atmospheric perspective (desaturated colors, and a pale bluish cast) to indicate great distance. Furthermore, the scattered orange roofs amidst the soft blue create a comforting rhythm.

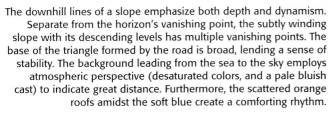

Curve vs. Straight Contrast Composition

- ■ **The contrast inherent in this composition creates a vivid and lively frame.**
- ■ **It makes the setting of the artwork more easily conveyed.**
- ■ **It tightens the frame, combining stability with a sense of movement and change.**

Curves and Straight Lines Enhance Each Other

Contrast is an important element to consider when constructing the frame of an illustration. By contrasting color gradations, strengths, light and shadow, they mutually enhance each other. Among these opposing attributes, the contrast between curves and straight lines can be striking. Adding soft curves to an illustration that features many straight lines will make the straight lines seem less stark. On the other hand, adding straight lines to a composition with many rounded curves emphasizes the softness of the curves, creating a vivid and lively image.

A frame without contrast tends to lack cohesion and gives and vague impression. There are situations when it might be better to avoid much contrast, depending on the theme you're drawing. But even if you want to emphasize a relaxed atmosphere, incorporating some contrast can make that impression stand out even more.

KEYWORD

Curves and Straight Lines
These different types of lines have contrasting attributes that enhance each other. Curves engender impressions like "organic," "feminine," "gentle" and "calm," while straight lines engender impressions like "man-made," "masculine," "immovable" and "modern."

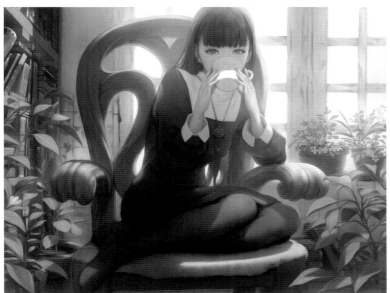

The straight lines of the window frame contrast with the gently arcing chair and the curvilinear form of the woman sitting in it, creating a gentle and beautiful image. Straight lines emphasize the subtle roundnesses. Also, by tilting the books on the left bookshelf slightly toward the character, the tension is relaxed, guiding the gaze toward the character.

The bright background circle's roundness contrasts with the straight shapes of the spear and forewings, as well as the powerful male character, emphasizing their angularity. By placing vivid red beads atop the unified dark foreground of the character and birds, the presence of the main character is emphasized, guiding the gaze to the face.

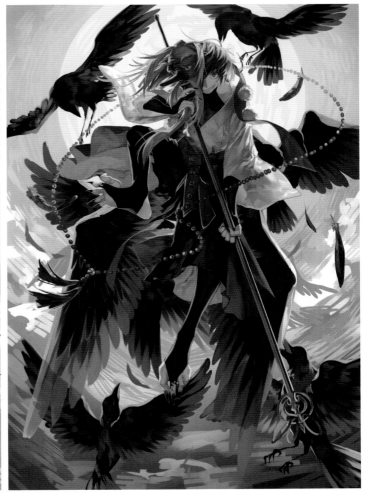

Zigzag Composition

- **This composition enables multiple elements to be well-balanced in the illustration.**
- **It naturally guides the viewer's gaze, allowing them to inspect the panel in a relaxed way.**
- **It connects the foreground and background rhythmically to enhance the sense of depth.**

A Carefree Flow of the Gaze

This composition arranges three or more elements in a zigzag. Multiple elements can be drawn in balance, and because the gaze naturally moves along the rhythmic line, it also provides a sense of security to view the image while following its flow.

Additionally, the zigzag shape evokes a sense of depth in the space. Diagonal lines running across the canvas create a sense of movement in their direction. By drawing a new diagonal line in the opposite direction from the end of this movement, the illustration's foreground and background are rhythmically connected. The Zigzag Composition allows artists to express a natural sense of rhythm and depth in a well-balanced manner.

KEYWORDS

Rhythm
This term refers to the pleasant repetition that occurs in a regular pattern. When there's rhythm in the panel, the gaze moves very naturally, and it can also create a sense of unity.

Sense of Depth
This term refers to the perception of faraway objects as being distant and nearby objects as being close. Emphasizing depth can also highlight the expansiveness of the space being depicted.

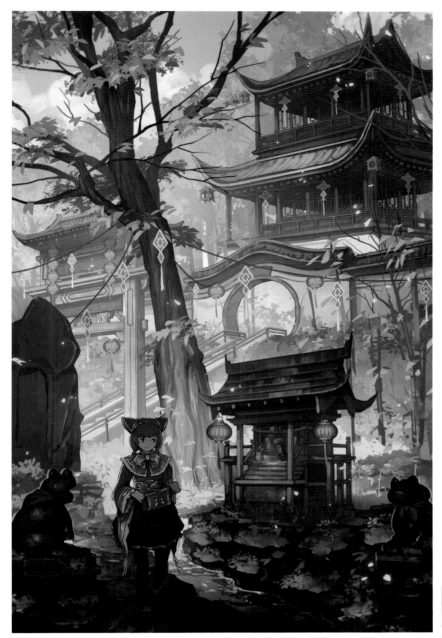

The viewer's gaze starts from the bright upper-left sky and gradually moves down, following a zigzag pattern, eventually landing on what the artist wants to emphasize (the character). As the gaze moves along, taking in the intricately drawn details in stages, the viewer can enjoy the entire illustration smoothly and without confusion. The contrast between the shaded foreground and the bright background enhances realism, providing the feeling that you're actually present in that scene.

Artist: nocras

Inverse Triangular Composition

- **This composition gives an impression of movement, instability and tension.**
- **It's effective for when you want to produce a sense of weightlessness.**
- **It can also be used to create a whimsical or comical impression by leaning into its inherent instability.**

An Effect Opposite to Triangular Composition

The inverted triangle composition, contrary to the stable triangle with a wide base, evokes a cool image of instability and tension. By arranging elements in an inverted triangle with its apex toward the bottom of the frame, you create a cohesive look. For example, objects that resemble a spinning top, with a large mass balanced on a single point, indeed give off an unstable impression. The object looks as if it's about to tip over, evoking feelings of unease and fear. Moreover, you can also exploit this precariousness to create a comical image. While it is a variant of the triangle composition, its effect is the complete opposite. Understand the attributes and remember them in conjunction with those of the regular Triangular Composition.

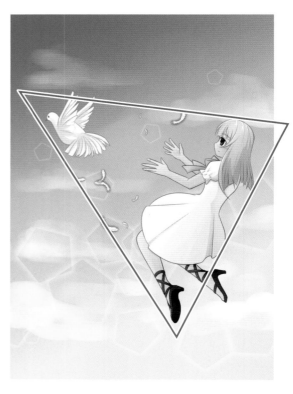

KEYWORD

Comical
Refers to a comedic and playful presentation. The unstable inverted triangle corresponds with the unpredictable, off-kilter element that comedy often possesses.

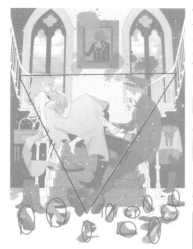

With a symmetrical background, the silhouette of two characters forms an inverted triangle, bringing a refreshing sense of dynamism. The contrast in tonality is striking, with the red carpet accentuating the blue-toned outfits of the characters. Moreover, the seemingly randomly placed shoes on the floor add a pleasant rhythm to the piece.

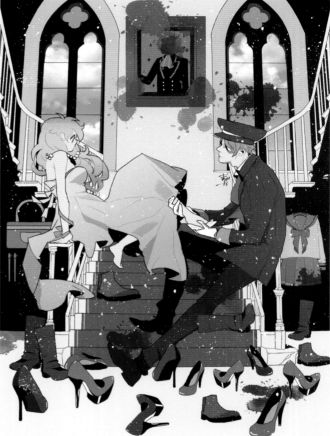

The inverted triangle composition is perfect for when you want to express swaying movements and a weightless impression. The lines created by the orange elements provide a sense of lightness and a comical impression. The character, surrendering to the embrace of the clouds, looks comfortable and at peace. The negative space around the character's face draws attention, maintaining a good balance and pleasing openness.

Compound Triangle Composition

- **This composition technique has been used in fine arts and other artistic endeavors since ancient times.**
- **It produces dynamism by combining several triangles.**
- **The effect varies depending on the shape of the triangles.**

Overlapping Triangles Create a Dynamic Composition

Traditionally, in the art world, triangles and rectangles have been regarded as highly compatible shapes. Even in illustrations, drawing a triangle in the center of a square canvas results in a stable composition. It gives viewers a sense of security and has a very natural effect.

Triangles can be formed not just by the silhouette of elements but also by the lines connecting major elements. You can also break down the illustration in detail and create it using smaller motifs. When drawing a single character, you might also compose it by overlapping several triangles. This brings movement to the piece, resulting in a dynamic impression.

Understand the features and effects of various triangle shapes, like equilateral triangles or inverted triangles, to effectively compose the image.

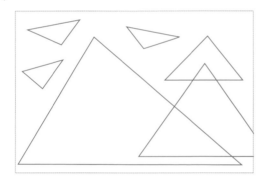

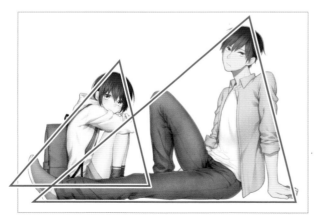

KEYWORD

Dynamism
This term describes the impression given by an image that seems energetic and lively. Illustrations overflowing with dynamism have the power to make you imagine scenes beyond what's depicted in the image.

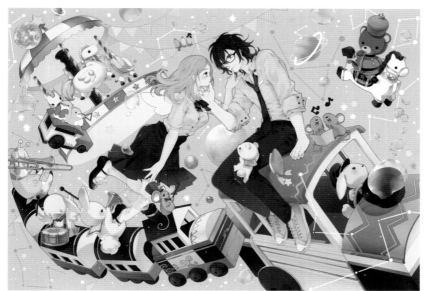

Various shapes of triangles float on this canvas, expressing a fun image. A large triangle formed by the character and the locomotive is at the center of the image, providing stability. So, even when numerous inverted triangles are scattered around, there's cohesion.

A wide-based triangle is placed at the bottom of the image for firm stability, and within it are triangles of characters and wave-dissipating concrete tetrapods for variation. The seagulls flying in the sky symbolize movement and form the lines of inverted triangles, whether taken individually or as a group. There's a good balance between uniformity and variation.

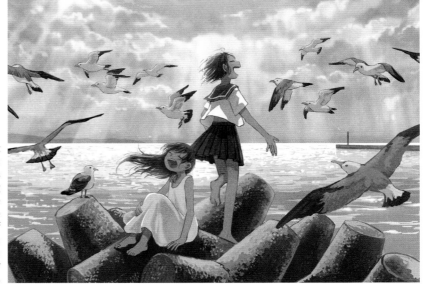

Diagonal Composition

- **This compositional technique capitalizes on the instability felt from a tilted horizontal framework.**
- **It can be effective for when the image seems too simple or is lacking in interest.**
- **Be careful not to tilt the angle excessively.**

Breaking the Horizontal-Vertical Structure to Introduce Movement

When objects that are usually horizontal, such as the sea or ground, are drawn on a slant, they can evoke a feeling of instability. By intentionally incorporating this sense of instability in a balanced manner, it's possible to express flow and movement in the image.

Not all illustrations need to be drawn strictly in horizontal or vertical perspectives. Intentionally showing a tilted viewpoint is also a valid technique.

Diagonal Composition can be used in various scenarios, such as to express the dynamism or lightness of a character, in battle scenes, scenes of being in a rocking vehicle, or in lyrical or emotional scenes. If you have a theme in mind but feel it is lacking in interest, it might be worth trying this method.

What's essential to note is the tilting angle. If you tilt it excessively, the feeling of instability will become overwhelming, so adjust while maintaining a good balance.

Studies show that most people instinctively have a slightly positive feeling about images with an upward slope to the right and a slightly negative feeling about those sloping downward to the right.

KEYWORD

Feeling of Instability

An unstable diagonal composition can create feelings of weightlessness or unease depending on its usage. It works particularly well with surreal fantasy illustrations.

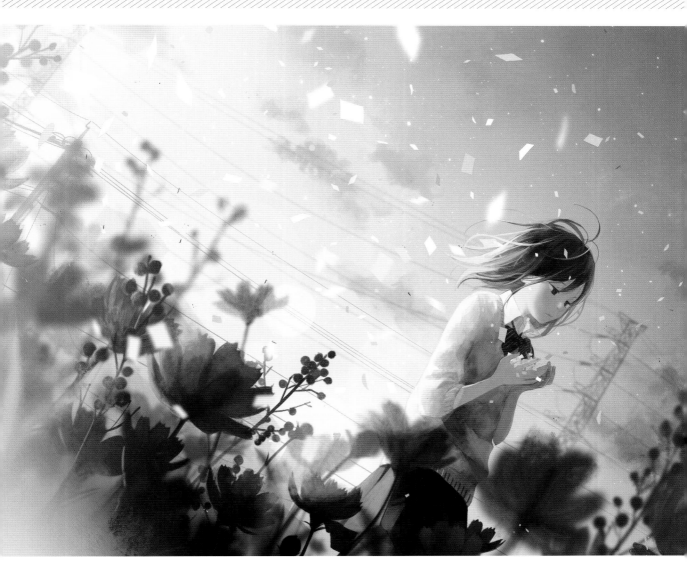

The illustration seems to reflect the character's emotions through its composition. The tilted angle combined with the flurry of small, wind-tossed paper bits from the character's hand dramatically conveys fluctuating emotions. It seems as though one could almost hear the sound of the wind from the image.

Pattern Composition

- **This composition entails lining up objects of the same shape to produce a pleasant visual rhythm.**
- **It introduces variation by deliberately breaking the regularity in one area to draw attention.**
- **This technique, which is also used in graphic design, results in a unique look given to your artwork.**

Creating Rhythm and an Organized Impression

Pattern Composition produces a layout with a unique graphic effect that is created by repeatedly using similar shapes or lines within a frame. Elements arranged in a pattern produce a pleasant rhythmic impression.

To highlight a pattern more distinctly, it's best not to mix different elements. However, introducing a different shape motif or a character with a unique pose amidst the regular pattern makes it stand out, guiding the viewer's gaze toward that character or motif.

Generally, the more repetitive the pattern, the more effective it becomes. A pattern composition makes for a potent layout where the composition method itself becomes the theme of the illustration. It expresses the uniqueness of the sculptural design and entertains the viewer.

KEYWORD

Pattern

Various motifs can be considered for patterns of aligned similar shapes. For instance, fruit hanging on a tree or windows lined up on a building's facade. Look for interesting shapes.

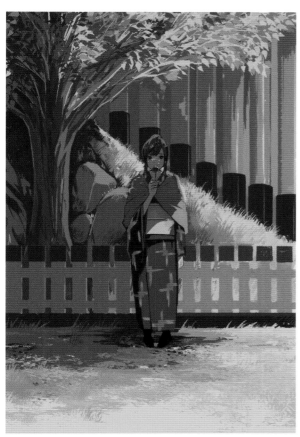

The patterns are formed by the evenly spaced vertical lines of pillars and fence planks. The repetition of the vermilion and black is rhythmic and eye-catching, making one imagine that it continues beyond the frame. Patterns can also be seen reflected in the kimono design, tree branches and leaves, creating well-balanced accents.

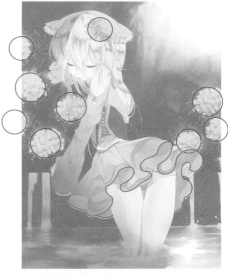

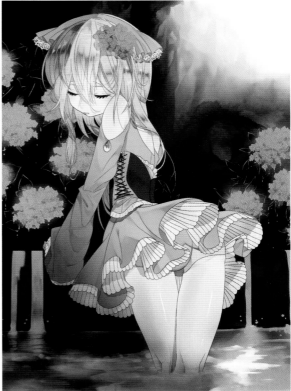

Inside a cave, luminescent flowers are arranged regularly, forming a pattern. The hem of the character's skirt resembles a flower, and it also presents a pattern reminiscent of flower petals and piano keys. The light pouring into the serene space, the bright atmosphere outside the entrance and the fluttering of the fabric create a unique ambiance. One can almost hear the faint sound of trickling water in this artwork.

Space and Time Composition

- The space in front of the character represents the future, while the space behind indicates the past.
- The perception changes based on which side of the frame, left or right, the space appears.
- This composition is useful for emphasizing a character's personality.

Right is the Past, Left is the Future (in Manga)

When planning an illustration where a character is turned to the side, it's customary to leave more space in front of the direction they're facing than behind. This results in a calm and comforting impression. This is because the front-facing space symbolizes the future. Conversely, allocating more space behind gives an impression of the past and feels sentimental. This is analogous to being "forward-thinking" for positivity and "backward-thinking" for negativity.

In Japanese illustrations and comics, there's a perceived timeline from right to left, as if an unseen wind is blowing. When you allocate space on the left side, creating an image of moving forward with the tailwind, it invokes feelings of "a bright future," "progress," "hope" and "momentum." On the other hand, the impression of moving against the wind and heading to the right resonates with feelings of "the past," "regression," "return," and "confrontation." Characters facing left exude a bright and light impression, while those facing right seem relatively darker. This principle is reversed in Western art.

Future Past

■ How Space is Portrayed and the Resulting Impression

❶ A running character appears as if they are being equally pulled from all sides, appearing frozen in the center.

❷ A cropped part of a character looks static, as if the character's feet are caught by the frame, preventing escape.

❸ Moving the character to the left introduces motion. It seems like the frame is pulling the character. The space behind the character represents the distance covered (the past).

❹ In a further progression of the drawing, the character appears to merge with the left edge of the frame, creating a static impression again.

KEYWORD

Space and Time
In illustrations and manga from Japan, the flow of time is represented as going from right to left. In Western art, where readers move through pages from left to right, the direction is flipped.

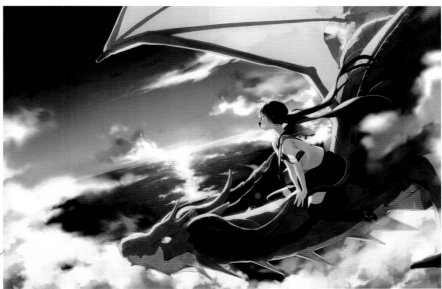

A red dragon stands out against a blue background, exhibiting a strong presence. This character advances gracefully, carried by the aforementioned conceptual wind blowing from right to left. The dragon's silhouette forms a triangle, giving a sense of stability, while its inverted triangular wings add dynamism. The wings also frame the character, guiding the viewer's gaze.

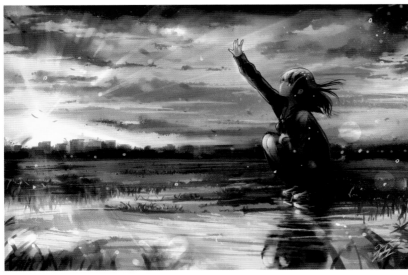

A character gazing up at the sky after the rain looks out across a large space on the left side, evoking images of the future, hope and youth. The color tone is darker on the right ("the past") and brighter on the left ("the future"). Organic bright artifacts float like musical notes, creating a gentle look. The reflection of the character and the light in a puddle form a symmetrical pattern, conveying a sparkling image.

Creating an Original Impression

For your work to have impact, it must communicate fresh ideas. Doing so will make it effortlessly stand out within the sea of other illustrations and manga. Composition techniques for creating a unique impression also require a good arrangement. Harness your creativity to craft an unparalleled visual design.

- ▶ Letter Composition
- ▶ Low-Angle / High-Angle Composition
- ▶ Wide-Angle Composition
- ▶ Telephoto Composition
- ▶ Panoramic Composition
- ▶ Packed Composition
- ▶ Bird's-Eye-View Composition
- ▶ Grouping Composition
- ▶ Panel Composition

Letter Composition

- ■ **This composition creates a feeling of security and attracts the viewer's attention.**
- ■ **It uses the shapes of letters as hints for motif placement.**
- ■ **It is observed not only in illustrations, but also in various visual designs.**

Leveraging Basic Design Techniques

People find comfort in familiar shapes like rectangles and circles. Capitalizing on this, Letter Composition incorporates the shapes of letters such as L, C and Y into the design. As most letters consist of combinations of rectangles, circles, triangles, etc., they provide a sense of security and attraction to the viewer. This composition technique is often seen in illustrations, sometimes intentionally and sometimes subconsciously. In particular, the L shape is a common motif seen in publications, advertisements, websites and other visual media. Incorporating the shapes of overlapping letters commonly found in company or sports team logos can also make for an intriguing composition.

■ **L Shape**

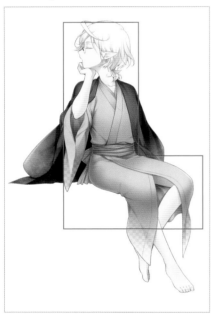

■ **C Shape**

■ **Overlapping Letter Shapes**

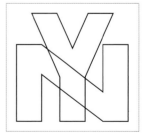

KEYWORD

Logos

Designs intended to serve as icons for organizations, companies or services. Due to their high visibility and simplicity, many logo designs are easily integrated into illustration compositions.

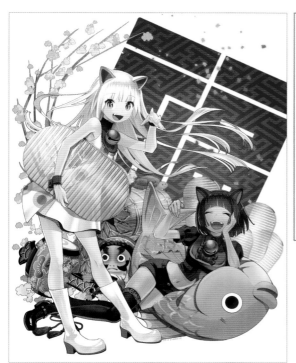

This image features a composition that places two characters within an L shape. By organizing elements within the letter shape, the image is neatly arranged and easily digestible. The contrast in color schemes is exquisite, fully conveying the charm of the cheerful characters.

Upon inspection, it's evident that this composition combines several overlapping letter shapes. There's the Y shape formed by the tree branch and the character, and the A shape created by the character and the chair. Additionally, one could say that the flow of the scarf and the chair leg form an R shape.

Low-Angle / High-Angle Composition

- **The angle looking up is called "low-angle," and the angle looking down is called "high-angle."**
- **The position of the eye level is crucial when considering this composition.**
- **The impression of the piece changes significantly depending on the eye level and angle.**

Considering the Position and Angle of the Viewpoint

When planning a composition, alongside element placement, it is crucial to determine where the eye level should be set. In photography terms, "eye level" refers to the height of the camera relative to the ground.

For instance, if you align the camera with the height of a character's face, that face height becomes the eye level. If aligned with the chest, then the chest height becomes the eye level.

To portray a high-angle view in your drawing, position the "camera" at a higher position aiming downward. Conversely, to portray a low-angle view, position the "camera" at a lower position aiming upward.

The viewer's impression of the subject will vary significantly between high- and low-angle portrayals. Try to determine the angle that is most compatible with the theme of your work.

■ How Does Camera Angle Relate to Eye Level?

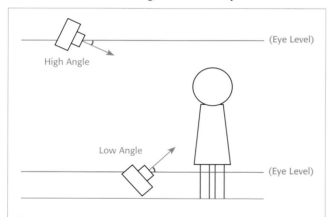

■ Low Angle

By drawing characters or buildings as if you're looking up at them, you can convey a sense of dynamism or power. It can also emphasize or exaggerate the height of the subject, producing feelings of intimidation or fear.

■ High Angle

With a high-angle view, you can depict a character from a more objective perspective, describing the surrounding situation or giving a broader view of the scene.

KEYWORDS

Eye Level
The height of the viewpoint. The ability to effortlessly draw scenes from different eye levels requires practice. Beginners should examine existing art to determine where the eye level is set.

"Angle"
This term refers to the camera's position, not necessarily its inclination. For instance, when shooting from ground level, even if the camera remains horizontal, it's still referred to as a "low-angle" viewpoint.

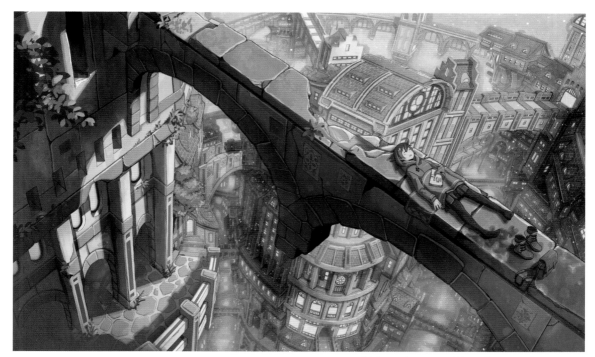

In a high-angle composition, there's a depiction of expansive space stretching downward and deeper into the scene. The wide frame objectively describes the world, while including details about the character's specific situation and expression.

Using a low angle to depict characters as if looking up at them emphasizes the vastness of the sky. Extraneous elements in the background are omitted to focus closely on the characters. The shimmering reflection of the pool water on the tent, bench and cooler evokes the excitement of summer vacation.

Wide-Angle Composition

- This composition can create an open and dynamic image.
- It emphasizes depth and produces a three-dimensional impression.
- Given the broad scope of the depiction, selecting essential elements to feature is crucial.

Depicting Dynamic Perspective and a Wide Scope

This composition captures a broad range as if shot with a camera's wide-angle lens, resulting in an open and dynamic portrayal. It's suitable for various scenes, from natural landscapes to urban mob scenes, and is also well-suited for exposition and establishing-shot situations.

The primary appeal of the Wide-Angle Composition lies in its emphasized sense of depth. Close-up elements appear larger than average, while those in the distance are relatively smaller, exaggerating perspective. This effect is also useful when incorporating elements like road lines into the image.

However, strengths can sometimes be accompanied by drawbacks. For instance, if the main character is positioned far away in a wide-angle shot, they might lose their prominence. Also, because it offers a wider view, there's the temptation to add more elements than necessary. It's essential to carefully plan what to depict and what to omit.

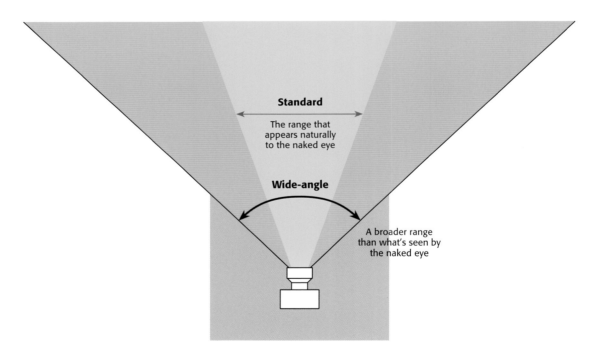

KEYWORDS

Wide-Angle Lens
A lens that can capture a broader range than what's visible to the naked eye. It's ideal for photographs of vast landscapes, making rooms appear larger or group photos with many people.

Dynamic
Implied vigor and energy—it is a term used not just for the overall scene but also for character poses. It gives a dramatic impression that draws in the viewer's gaze.

Mob Scene
A depiction of a crowd or multitude. In illustrations, manga or video games, a scene with many people is referred to as a "mob scene."

Because the characters are intentionally positioned where they don't obstruct the depth axis of the perspective, the background seems to stretch far away, conveying a sense of immersion. The white moth in a crumbling setting evokes a flicker of hope amid the ruins. With a wide-angle composition, first showcasing the entire scene and then letting the eyes wander to details allows for new discoveries, enhancing the enjoyment. It's essential to skillfully guide the viewer's gaze.

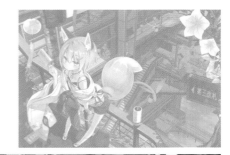

This is a dynamic wide-angle representation from a high angle. It's a perfect example of how an illustration can depict angles that would be challenging to capture with a camera. By bringing the main character up close while also paying attention to distant background details, the depth and the expanse of space is emphasized.

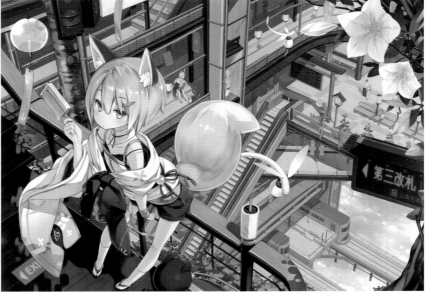

Telephoto Composition

- This is a composition that zooms in on the main subject, capturing a narrow range.
- It creates a dramatic impression with a blurring effect.
- It simply conveys the artwork's intent due to limited number of elements that can be portrayed.

Highlighting the Main Character and Amplifying Emotion

A Telephoto Composition is one that looks as if it was drawn after capturing a narrow range using a telephoto lens. It is an ideal composition for depicting a scene from a sports event in a stadium as if viewed from a distance, or for showing distant animals as if they were right in front of you. Overlaying elements from both the foreground and background dynamically can be an effective technique.

One of the features of the Telephoto Composition is the "blurring effect" (*bokeh*). This replicates the phenomenon in photography where the more compressed the depth of field becomes, the more the out-of-focus areas increase. It can provide a dramatic impression, especially in compositions where a single character is isolated.

Also, because it captures a narrow range, there are fewer elements that can be depicted, making the composition more straightforward. Eliminating unnecessary elements conveys the artist's intent simply, making it suitable for scenes where you want the focus to be clear.

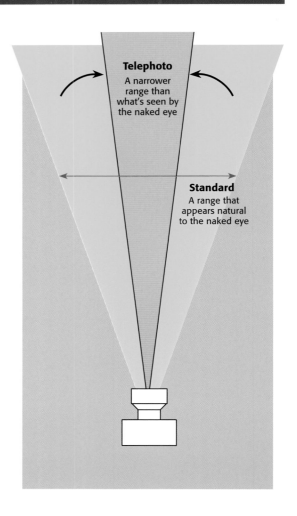

Telephoto
A narrower range than what's seen by the naked eye

Standard
A range that appears natural to the naked eye

KEYWORDS

Telephoto Lens
A lens that captures a narrower range than what's visible to the naked eye. It produces an image that looks as if you have come very close to the subject. There's an effect where the depth between objects seems more compressed than in reality.

Bokeh
A Japanese photography term that refers to the blurred effect and the quality of that blur. Blurring the background makes the main subject stand out more prominently.

The character is boldly zoomed in on, giving the impression that the girl is right in front of you. Being able to see her expression clearly allows her emotions to be directly conveyed. The artwork excels not only in expressing emotion but also in representing the texture of hair and skin, as well as the fabric of the clothing, resulting in a work brimming with emotion.

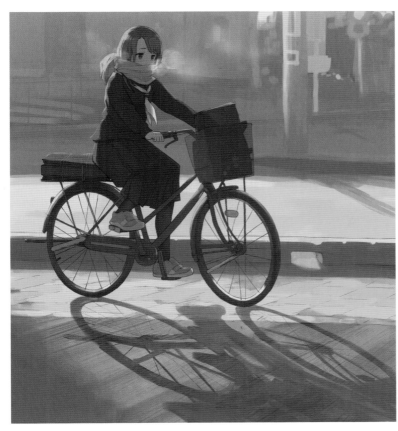

By focusing sharply on the somewhat distant character and imagining the blurring effect of a telephoto lens, the areas in front of and behind the character are blurred. The atmosphere of a chilly morning and the character's visible breath as they head to school provides a sense of immersion, allowing viewers to empathize with the character.

Artists: (Top) 和遥キナ　(Bottom) もりちか

Panoramic Composition

- **This is a composition with a wide-angle, irregular frame, creating a strong visual impact.**
- **It can be used to express a free and relaxed image.**
- **Achieving balance in the frame is challenging, requiring a good sense of design.**

Creating a Feeling of Freedom and Openness

A Panoramic Composition is a layout that is horizontally or vertically elongated, allowing one an overview of a vast area. Due to its lack of constraint, it offers a free and relaxed impression, allowing viewers an uninhibited look at the artwork.

When drawing an illustration with unconventional dimensions like the Panoramic Composition, it's important to effectively use contrast throughout the entire canvas. For instance, when multiple characters are introduced, depending on their arrangement, the artwork might lack contrasts, making it difficult to distinguish between main and supporting characters.

While the Panoramic Composition allows for free, enjoyable drawing, balancing the whole image is challenging. To use the wide angle of view and bring everything together harmoniously, the artist's experience and sense of design are crucial.

KEYWORD

Angle of View
Refers to the range depicted in the frame. In illustrations, any angle, whether extremely wide or tall, can be expressed. Capture any scene as you wish!

The artwork provides a very free, open feeling that creates a pleasing image for the viewer. You can sense the crisp, clean air practically emanating from the illustration. Additionally, the varying sizes of the clusters of pampas grass stalks form triangles, giving stability while emphasizing the vast depth of the space. The curving flow of the clouds gently directs the viewer's gaze toward the character.

Packed Composition

- **This composition is filled with many detailed motifs to give a sense of density.**
- **It create spaces that feel like breezes could flow through.**
- **Adjust the amount of information in the illustration while considering the viewer's perspective.**

Creating "Breathing Space" for Air to Flow

When many elements are packed into a frame, the artwork has a lot of information, resulting in a lively, fun and active image. On the other hand, reducing elements gives a cool and calm impression. The impression of an illustration can drastically change based on the amount of elements and information presented to the viewer. Offering the viewer an amount of information that aligns with the theme is a testament to an illustrator's skill.

In the case of a Packed Composition, it's important to create spaces or pathways for "airflow," contrasted against the density of the rest of image. Only with these "breathing spaces" can the liveliness and fun of the density be highlighted.

If there's too much information in the panel, it can be overwhelming, while too little can leave the viewer unsatisfied. Always aim for an objective viewpoint when planning the composition.

Space (Pathway for Air)

KEYWORDS

Breathing Space
Keeping open margins or gaps. A panel packed from corner to corner can feel oppressive.

Information Density
Apart from motif density, color scheme and level of detail can also significantly influence this metric. The amount of information varies between a simple line drawing filled in with one color and a detailed, cluttered drawing painted with multiple colors.

A character surrounded by numerous books. By showing a lot of information in each area, it effectively communicates to the viewer. The background area dominated by black, the colorful spines of the books on both sides, the ukiyo-e poster behind the character... This piece resembles contemporary art or an installation, where the viewer is compelled to experience an entire space, such as an antique bookstore, incorporating elements like light, objects and text.

This composition is dense and jumbled, yet there's a well-balanced rhythm. The colors red, yellow, blue, green, white and black are used in a pop-art style, and they are placed in a distributed, pleasingly rhythmic manner. The choice to leave certain spaces completely empty is also effective. The distortion at both ends of the image, as if viewed through a wide-angle lens, lends an indefinable charm.

Bird's-Eye-View Composition

- This composition features a top-down perspective.
- This unusual angle of view makes a strong impact.
- Characters lying down or plates of food evoke strong interest when depicted from this angle.

A Composition Popular on Social Media

From a high position (high angle), when looking down, this perspective is referred to as "bird's-eye view"—particularly when it's depicted from directly overhead.

Imagine a character lying on the ground viewed from directly above, or photos of dishes containing food resting on a table. Such shots have potent impact and are a common sight in photos posted to social media.

KEYWORD

High Angle Bird's-Eye View
This term describes the technique of depicting a lofty vantage point that is angled downward to capture the subject below. When illustrating a steep angle, it becomes challenging to depict the sense of depth correctly, so be careful to show accurate perspective when drawing.

Here is a very unique piece that seems to squeeze all the essentials of life into a small room. The Bird's-Eye-View Composition is effectively displayed. Items are lined up following the one-point perspective lines, allowing viewers to enjoy the intricate details without confusion.

A Bird's-Eye-View Composition where a character lying down, roses and organically shaped tiles are viewed from directly above. Within this frame, only the black cat is facing not upward, but at the reclining person. Through this, the viewer's gaze is compelled to follow the cat's gaze straight toward the character's face.

Grouping Composition

- **This composition features grouped elements that exhibit the same characteristics.**
- **Order gives the illustration a sense of organization, resulting in a stable visual.**
- **Multiple grouped elements contrast with each other, provoking the viewer to imagine their relationships.**

Highlighting the Narrative Within the Artwork

When there are many elements in the illustration, grouping items of similar color, shape, size, etc., is termed "grouping" (or "clustering"). By using grouping in illustrations, visual clutter is reined in, and order is maintained.

Furthermore, a sense of tension arises from the contrasts between grouped clusters. This contrast crafts a narrative in the image and conveys the creator's intent more clearly.

Principles of Grouping

- Items that are alike tend to form groups when they are closer together.
- Things with the same attributes, like color, shape and texture, group together regardless of distance. In this case, color tends to have a stronger grouping tendency than shape.
- Items moving similarly are perceived as a single group.

On the table, fruit is scattered without cohesion. It's unclear where the viewer should focus.

By clustering the fruit in three places—on a plate, on a cloth and in a basket—a contrasting structure emerges, giving the image a more cohesive look.

KEYWORD

Matière

A French word that refers to the texture or feel of a motif. Depicting different textures, like metal or fabric, is essential for communicating with the viewer. In the art world, it is sometimes referred to as the "blood and bone" (or "texture," "skin," etc.) of a painting.

Books crammed onto library shelves are orderly and neatly grouped. The ceiling decoration is also grouped, intricately and beautifully drawn following the perspective. This artwork depicts a vast space from a low angle without any sense of unease, with the character's gaze directed at the viewer. It makes the viewer feel as if they might be another cat on the floor, looking up at the character.

Expressive chibi characters are grouped and positioned in the four corners. Each group forms a triangle, creating a sense of stability and movement in the image. Patterned flowers and leaf decorations are also divided into separate areas and grouped, emphasizing the main character.

Panel Composition

- This composition technique is useful for illustrating multiple scenes on a canvas, similar to manga panels.
- It's effective for when you want to contrast different spaces, or indicate the passage of time.
- Varying the shapes and arrangement of the panels can make the image more dynamic.

A Magical Composition Transcending Time and Space

This technique divides a single picture into multiple scenes, akin to manga panels. It allows for several scenes to be depicted on the same canvas. The space between the panels signifies various transitions, such as changes in location or the passage of time. It also conveys a lot of information, making it suitable for expressing a story or setting a scene.

This approach can magically encapsulate the past, present and future, the realms of reality and imagination, and even distant cosmic spaces spanning billions of years within a single image. By demarcating each scene, the canvas becomes organized, making it easier for the viewer to understand the artist's intent. However, there's a risk of it becoming overly structured, which can feel stiff. To add variety, consider changing the shape of the panels or allowing characters to overlap or break out of their confines.

KEYWORDS

Setting Depiction
This refers to illustrating the backdrop or the circumstances that led to a particular scene. Due to Panel Composition's ability to encompass different times and places in one image, it becomes easier to depict these settings.

Reality and Imagination
These terms obviously denote the distinction between the real world and fantasy. Concepts like parallel worlds also fall under this category. With Panel Composition, not only can you leap across time and space, but you can also traverse different worlds.

The same character is depicted at the same angle in two frames, expressing changes in time (night and day) and location (ground and sky). The view from the window, the light from outside and the airplane's interior lighting illuminate the character's face, emphasizing contrast. The subtle shift in the character's mood is conveyed through the depiction of the eyes.

"Books to Span the East and West"

Tuttle Publishing was founded in 1832 in the small New England town of Rutland, Vermont [USA]. Our core values remain as strong today as they were then—to publish best-in-class books which bring people together one page at a time. In 1948, we established a publishing outpost in Japan—and Tuttle is now a leader in publishing English-language books about the arts, languages and cultures of Asia. The world has become a much smaller place today and Asia's economic and cultural influence has grown. Yet the need for meaningful dialogue and information about this diverse region has never been greater. Over the past seven decades, Tuttle has published thousands of books on subjects ranging from martial arts and paper crafts to language learning and literature—and our talented authors, illustrators, designers and photographers have won many prestigious awards. We welcome you to explore the wealth of information available on Asia at **www.tuttlepublishing.com**.

Published by Tuttle Publishing, an imprint of Periplus Editions (HK) Ltd.

www.tuttlepublishing.com

ISBN 978-4-8053-1801-0

ILLUST, MANGA NO TAMENO KOZU NO BYOGA KYOSHITSU
Copyright © 2018 SHINJI MATSUOKA
English translation rights arranged with MdN Corporation through Japan UNI Agency, Inc., Tokyo

English translation © 2024 Periplus Editions (HK) Ltd

Library of Congress Cataloging-in Publication Data is in process.

26 25 24 10 9 8 7 6 5 4 3 2 1
Printed in China 2406EP

TUTTLE PUBLISHING® is a registered trademark of Tuttle Publishing, a division of Periplus Editions (HK) Ltd.

Distributed by
North America, Latin America & Europe
Tuttle Publishing
364 Innovation Drive,
North Clarendon,
VT 05759-9436, USA
Tel: (802) 773-8930; Fax: (802) 773-6993
info@tuttlepublishing.com
www.tuttlepublishing.com

Japan
Tuttle Publishing
Yaekari Building 3rd Floor
5-4-12 Osaki
Shinagawa-ku
Tokyo 141-0032
Tel: (81) 3 5437-0171; Fax: (81) 3 5437-0755
sales@tuttle.co.jp
www.tuttle.co.jp

Asia Pacific
Berkeley Books Pte. Ltd.
3 Kallang Sector #04-01
Singapore 349278
Tel: (65) 67412178; Fax: (65) 67412179
inquiries@periplus.com.sg
www.tuttlepublishing.com